Hidden Language of Flowers

A Coloring Compendium

VALENTINA HARPER

Welcome to a World of Meanings!

Flowers are more than just an eye-catching aspect of nature. Over the centuries and across cultures, flowers have taken on important meanings. From holy flowers to flowers representing concepts like friendship and strength, you'd be surprised at just how many meanings people have ascribed to the beautiful blooms that surround us. Enjoy coloring and learning the language of flowers!

Visit Valentina and see more of her work at *www.valentinadesign.com.*

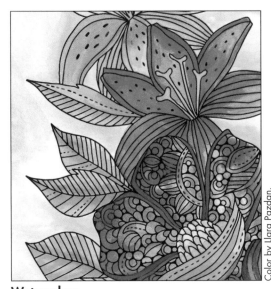

Watercolors

Color by Llara Pazdan.

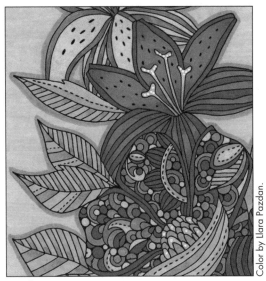

Markers

Color by Llara Pazdan.

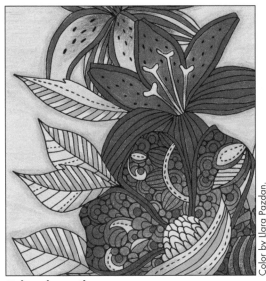

Colored pencils

Color by Llara Pazdan.

ISBN 978-1-4972-0452-2

Fox Chapel focuses on providing real value to our customers through the printing and book production process. We strive to select quality paper that is also eco-friendly. This book is printed on archival-quality, acid-free paper that can be expected to last for at least 200 years. It meets the minimum requirements of the American National Standard for Information Sciences—Permanence of Paper for Printed Library Materials, ANSI/NISO Z39.48-1992. This book is printed on paper produced from trees harvested from well-managed forests where measures are taken to protect wildlife, plants, and water quality.

© 2020 by Valentina Harper and New Design Originals Corporation, *www.d-originals.com*, an imprint of Fox Chapel Publishing, 800-457-9112, 903 Square Street, Mount Joy, PA 17552.

Cover art colored by Llara Pazdan.

We are always looking for talented authors. To submit an idea, please send a brief inquiry to acquisitions@foxchapelpublishing.com.

Printed in Canada
First printing

My Process

I begin everything by hand with just a blank sheet of paper and a pencil. After capturing in pencil the shape of whatever it is that I'm going to draw, I start filling the shape in with designs in black ink. When the figure is filled with details, I scan it, and voila! Now you have a nice design to color.

I like to work at my sunlit desk!

Here I've started to fill in a design outline with details like dense stripes and circles.

A pile of finished designs.

About Me

My name is Valentina Harper and I grew up in Venezuela, where my childhood was filled with drawing, coloring, and painting. As an adult, I came to the United States with a brilliant imagination and a heart full of dreams. After getting a degree in graphic design and working for fifteen years as a graphic designer, I discovered a new life as a professional artist. In my Nashville studio, I spend countless happy hours playing with my paints and my pens, nurturing my world of fantasies and dreams where my uplifting drawings and designs take shape. I enjoy working with different materials, but black ink is one of my favorite mediums. My attention to intricate detail is my signature drawing style.

My home studio has plenty of work surfaces, coloring supplies, and inspiring art to surround me while I work.

3

Introduction to Coloring

There is a wide range of colors available to you, but you can also use many different techniques to apply color. Here are just some ideas to get you started! As you make your coloring choices, remember that everything is allowed. You can mix techniques, colors, and tools however you want to put the finishing touches on your piece. The important thing is for you to relax and enjoy the process!

Color large areas: Color each section of a drawing in one single color. There's no need to get caught up with coloring each and every little tiny shape separately if you don't want to.

Use a monochromatic color palette: Use only different shades of the same color on a design. Choose any single color (primary, secondary, or tertiary!) and play with various shades of it—for example, use different dark pinks and reds with light pinks for accents.

Alternate colors: Within each section of a design, color each small shape in alternating colors. Try using two similar colors in each section, like the light and dark pink, light and dark brown, and light and dark orange shown here.

Use shading: Within specific spaces or areas of a design, play with the intensity of the color you've chosen. Especially with tools like colored pencils, you can simply press lighter or harder with the tool to go from a lighter color to a darker color and achieve a gradient effect across an area. This can add real dimension to a coloring.

Use white space: Leave some areas of a coloring white to add a sense of space and lightness. This can work really well with light color schemes, but can also create a cool, bold effect with dark color schemes.

Tip

If you're working directly in your coloring book, take care of the book by putting a blank sheet of paper underneath the page you're coloring with to prevent the ink from bleeding through onto the next design. You can also put a sheet of paper underneath your hand while you're coloring—this will prevent your hand from accidentally smearing the color already on your work.

The History of Flower Language

Symbolism for Ancient Cultures

Throughout human history, flowers have been used to symbolize different ideas and feelings. Many cultures have drawn inspiration from religion, myths, and folklore and have attributed meaning to certain plants. Lotus flowers, for example, were very important to the ancient Egyptians. Because the blooms open in the morning and close at night, lotuses represented the path the deceased took into the underworld and into their new life.

Lotus

During ancient Greek and Roman times, myrtle was associated with Aphrodite/ Venus and symbolized love and desire. Not only was the goddess of love often depicted wearing the flower, but myrtle trees were planted in temple gardens and shrines that celebrated the goddess. Brides-to-be took myrtle-scented baths before their wedding. Newlyweds often wore myrtle wreaths.

Flowers and Literature

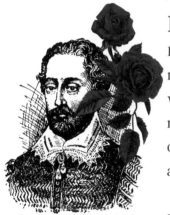

Edmund Spenser (1552-1599)

Flowers have always been used as symbolic objects in classic novels, plays, and poetry. Edmund Spenser's Sonnet 64 is filled with floral symbolism ("her ruddy cheeks lyke unto roses red"). The poem's narrator compares the woman he loves to different plants and flowers in various ways. The flora is used as a way to convey the narrator's adoration for her.

Myrtle flowers and Aphrodite (Greek)/Venus (Roman)— the goddess of love

Flower symbolism in literature is also seen in William Shakespeare's *Hamlet*. In Act 4, the character Ophelia hands out flowers to several people in a room, which includes the queen and king: "'There's rosemary, that's for remembrance, pray you, love, remember. And there's pansies, that's for thoughts . . . there's fennel for you, and columbines.'" She bravely condemns the king and queen by ironically giving them columbine—a symbol of a faithfulness. Hamlet's mother had shown no loyalty to her murdered husband by marrying the man who had killed him—Hamlet's uncle. Ophelia uses flowers and their meanings to communicate what she can't say aloud.

William Shakespeare (1564-1616)

Popularity in the Victorian Era

Rules Galore

Using flowers as a way to communicate was probably most popular during the Victorian era in England (1837–1901). This was especially true for the upper class, since there were many social rules about what they could and could not talk about in public. There were certain topics (such as emotions or bedroom activities) that well-to-do Victorians would never talk about because they were considered undignified or impertinent. In a time when a person's reputation was very important, one of the safest ways to communicate taboo ideas was through flowers.

Presentation Mattered

Almost every upper-class Victorian home had a Bible and a "floriography" (language of flowers) guidebook. When a lady received a bouquet of flowers, she consulted her guidebook and deciphered not only the meaning of all the flowers but also the arrangement and colors. For example, if a bow was tied to the left, this indicated that the message applied to the sender; if tied to the right, the message was about the receiver. If a bouquet was delivered upside down, it meant the flowers all took on the opposite of their meaning.

Yes or No

How a flower was physically given to another person could give a straightforward "yes" or "no" answer. When a flower was presented with the right hand, the receiver was to understand that it meant yes; the opposite was true with the left hand. Flowers didn't even have to be physically handed to another person to get a "yes" or "no" answer. If flowers were held at heart level, that meant yes. If they were held with the blooms facing the ground, the answer was no

Colors and Patterns

The colors of the flowers were very important for some plants, to relay the correct meaning. Many times, the type of flower wasn't enough to convey a secret message; each color had its own meaning, too. Red roses, for instance, symbolized romance, but yellow roses were used to send a message of friendship.

The meaning of some flowers even depended on the patterns of their petals. Carnations have both solid and striped variations. Solid-colored petals each had their own meaning, depending on the color. Striped carnations were always used to reject a suitor—a floral way to say, "I'm not interested."

Flower Meanings in This Book

A list of flowers, their meanings in this book, and the pages they can be found on is provided. It includes art that has the name and meaning as part of the image as well as the ones that do not have any text in the art. The pages that have prompts for writing or drawing, fill-in patterns, or a general theme or quote are not included in this list. With these coloring pages, you can color a flower, cut out the image, and give it to someone to express a specific feeling or idea!

Striped and solid carnations had different meanings!

Page	Flower	Meaning	Page	Flower	Meaning
25	Olive	Peace	82	Delphinium (larkspur)	Lightness and joy
26	Tiger lily	Wealth	84	Snowdrop	Hope, rebirth
30	Daffodil	Rebirth and new beginnings	86	Peruvian lily	Friendship, devotion
34	Cactus flower	Maternal love	90	Bush lily	Enjoyment
36	Hollyhock	Fertility	91	Dahlia	Confidence
39	Cedar	Strength	95	Statice (sea lavender)	Remembrance
40	Anemone	Protection and anticipation	96	Lisianthus (bluebell)	Gratitude
44	Apple blossom, white poppy, violet, basil, lavender	Peace	98	Wallflower	Fidelity
46	Morning glory	Duality, meaning either love or mortality	100	Ivy	Endurance
50	Pincushion flower	Love, purity, and peace	103	Black-eyed Susan	Justice
52	Jonquil	Desire	104	Forget-me-not	Remembrance
55	Black tulip	Power	106	Anthurium	Hospitality
56	Wild geranium (cranesbill)	Friendship, happiness, and positive emotions	107	Protea (sugarbush)	Courage
58	Rose myrtle	Love	111	Valerian (garden heliotrope)	Health and strength
59	Panama rose	Endurance	115	Zenobia (honeycup)	Independence
62	Bearded crepis (hawk's-beard)	Protection	116	Lewisia (bitterroot)	New beginnings
63	Jasione (sheep's bit)	Justice	118	Phlox	Harmony
64	Begonia	Caution	119	Water-willow	Freedom
66	Mulberry	Wisdom	120	Peony	Prosperity
67	Bird of paradise	Joy	122	Aster	Patience
69	Gerbera daisy	Cheerfulness	124	Edelweiss	Adventure and devotion
70	Mallow	Love, protection, and health	126	Chrysanthemum, blue tulip, zinnia, iris	Friendship themes
73	Sleepy-daisy	Endurance	129	Horehound	Health
75	Heather	Admiration, beauty, and good luck	130	English daisy	Purity and innocence
78	Hyacinth	Playfulness	133	Passion flower	Passion
79	Gardenia	Good luck, purity	134	Calla lily	Rebirth and strength
80	Camellia	Innocence, romance, passion	136	Quesnelia	Endurance and hardiness
			137	Jasmine	Grace
			140	Yucca	Purification
			141	Felicia (Marguerite daisy)	Happiness
			143	Lucerne (alfalfa)	Life

PATTERN SAMPLES

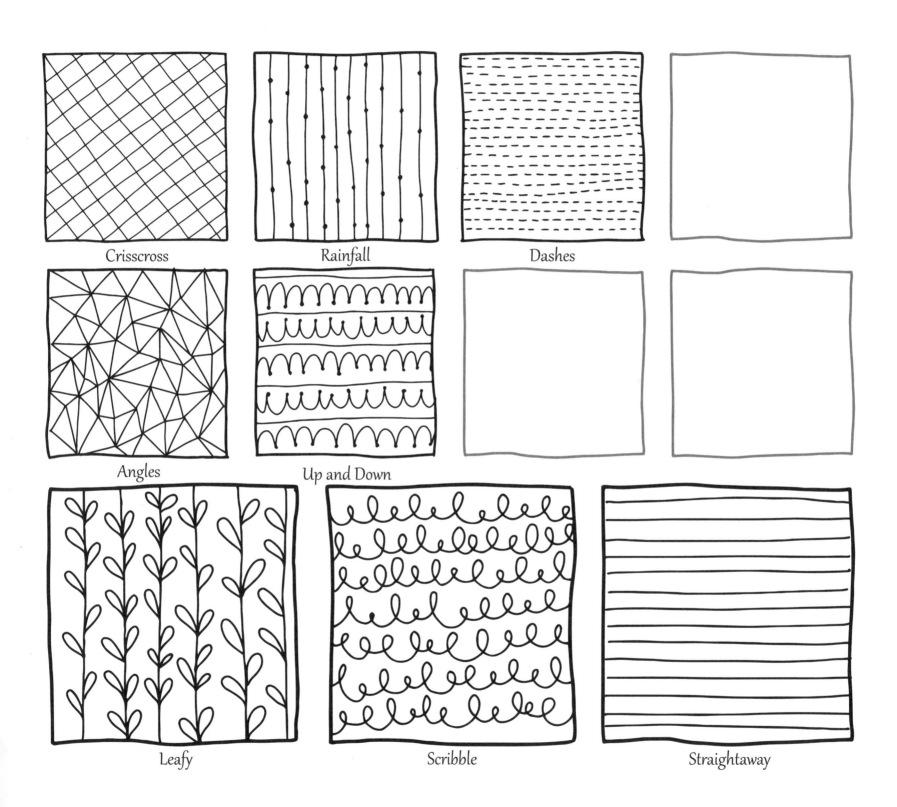

Crisscross

Rainfall

Dashes

Angles

Up and Down

Leafy

Scribble

Straightaway

Enhance your coloring by adding patterns. Here are some examples to try, or create your own.

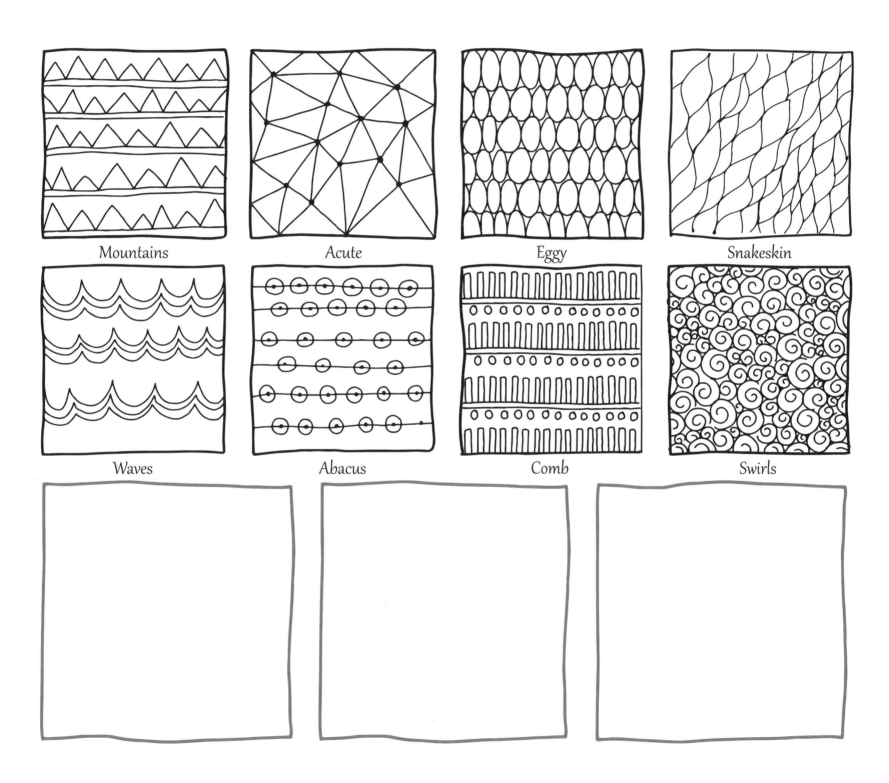

Mountains

Acute

Eggy

Snakeskin

Waves

Abacus

Comb

Swirls

PATTERN SAMPLES

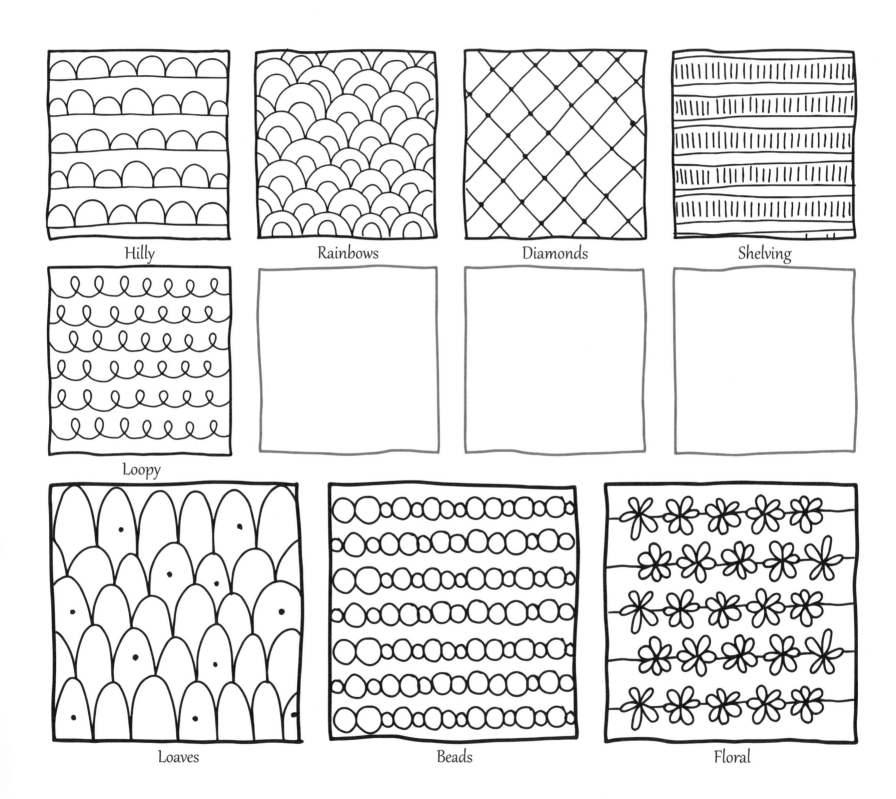

Hilly

Rainbows

Diamonds

Shelving

Loopy

Loaves

Beads

Floral

"Art is the imposing of a pattern on experience." –Alfred North Whitehead

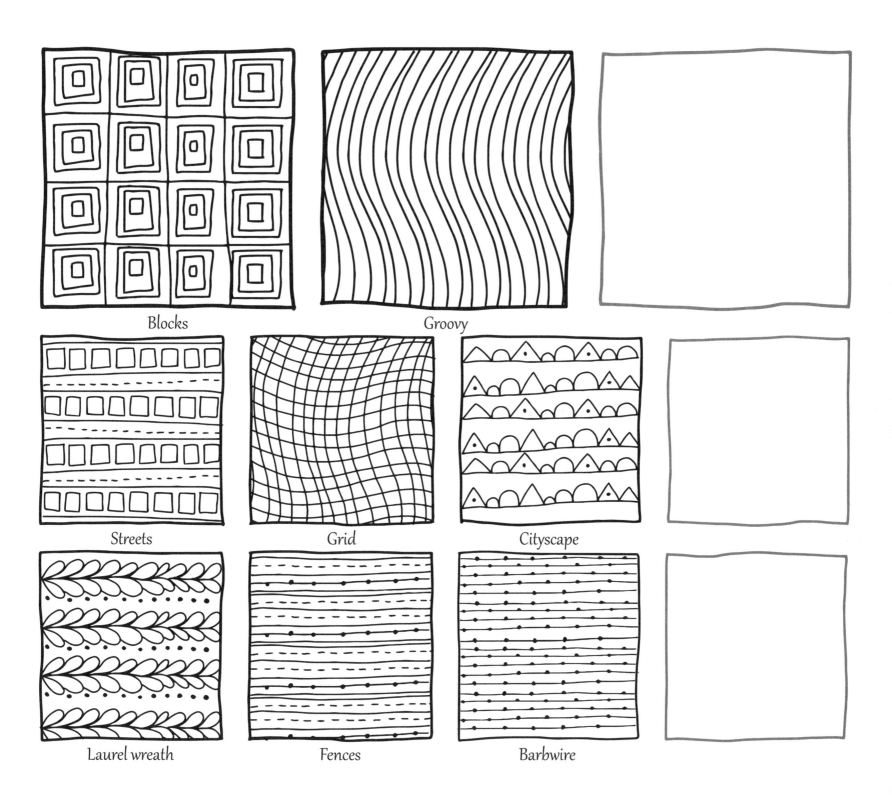

Blocks

Groovy

Streets

Grid

Cityscape

Laurel wreath

Fences

Barbwire

FLOWER SAMPLES

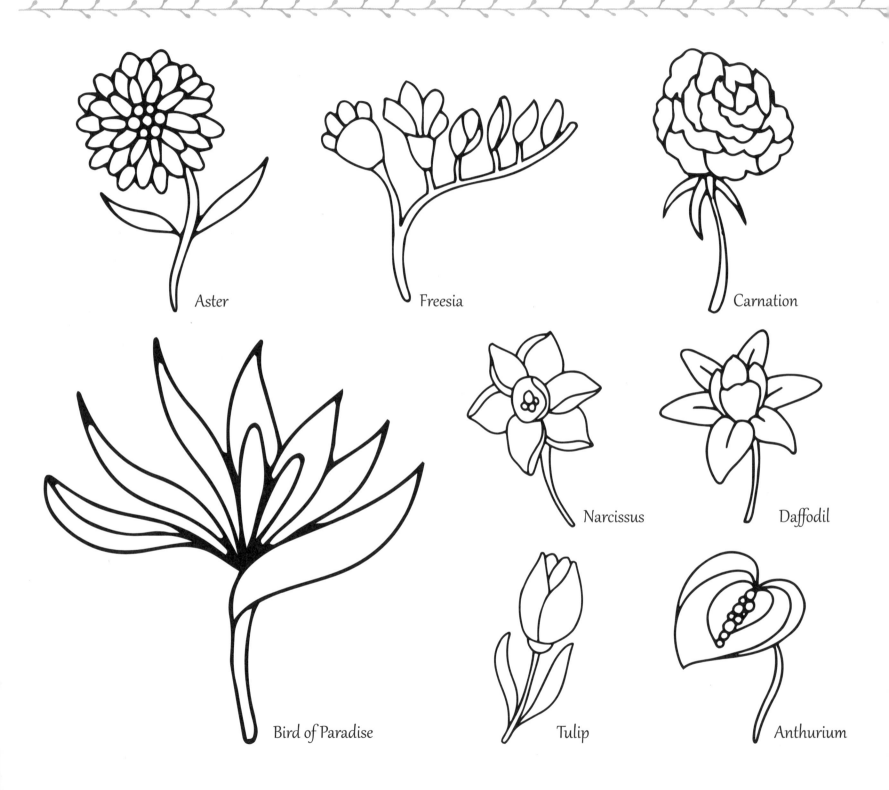

Aster

Freesia

Carnation

Bird of Paradise

Narcissus

Daffodil

Tulip

Anthurium

Draw your own flowers to pattern and color. Lay a blank sheet of paper over a flower and trace it to practice. Then try drawing these designs on your own!

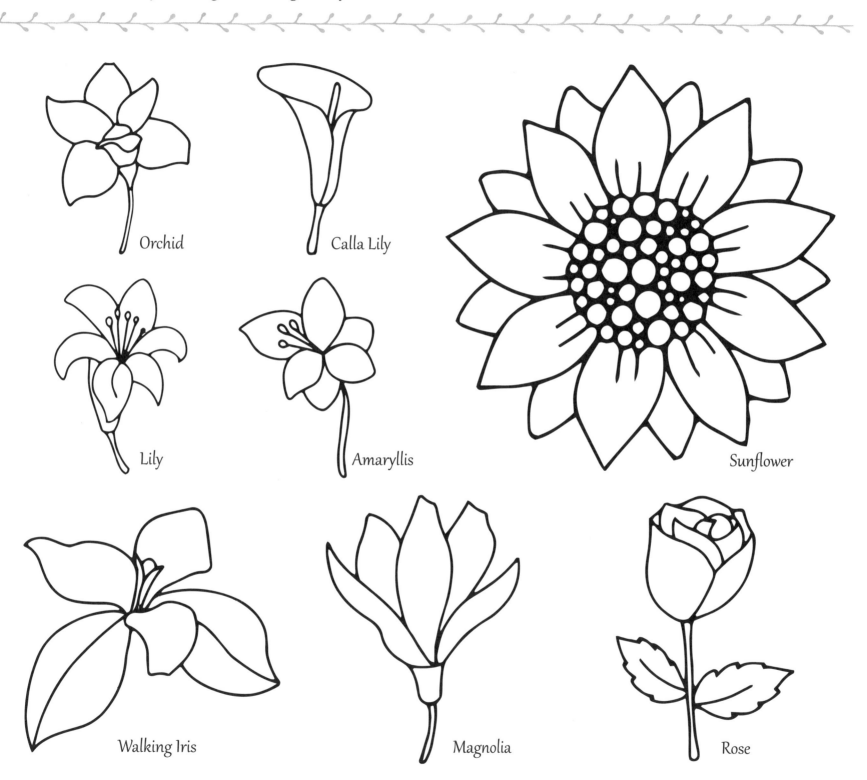

Orchid

Calla Lily

Lily

Amaryllis

Sunflower

Walking Iris

Magnolia

Rose

FLOWER SAMPLES

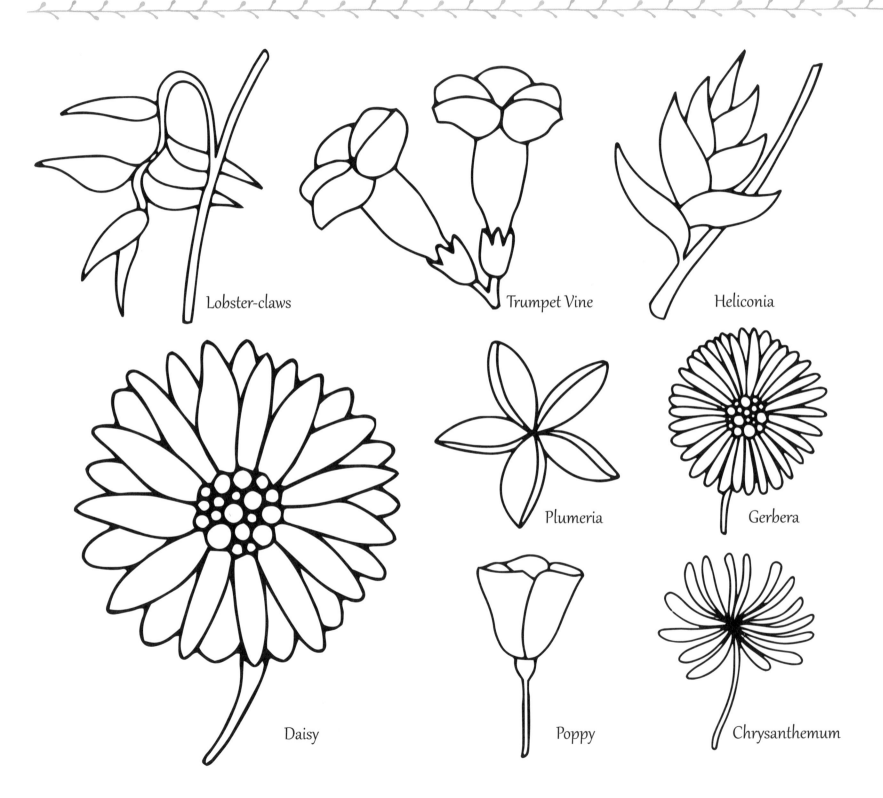

Lobster-claws

Trumpet Vine

Heliconia

Daisy

Plumeria

Gerbera

Poppy

Chrysanthemum

"I sometimes think there is nothing so delightful as drawing." –Vincent van Gogh

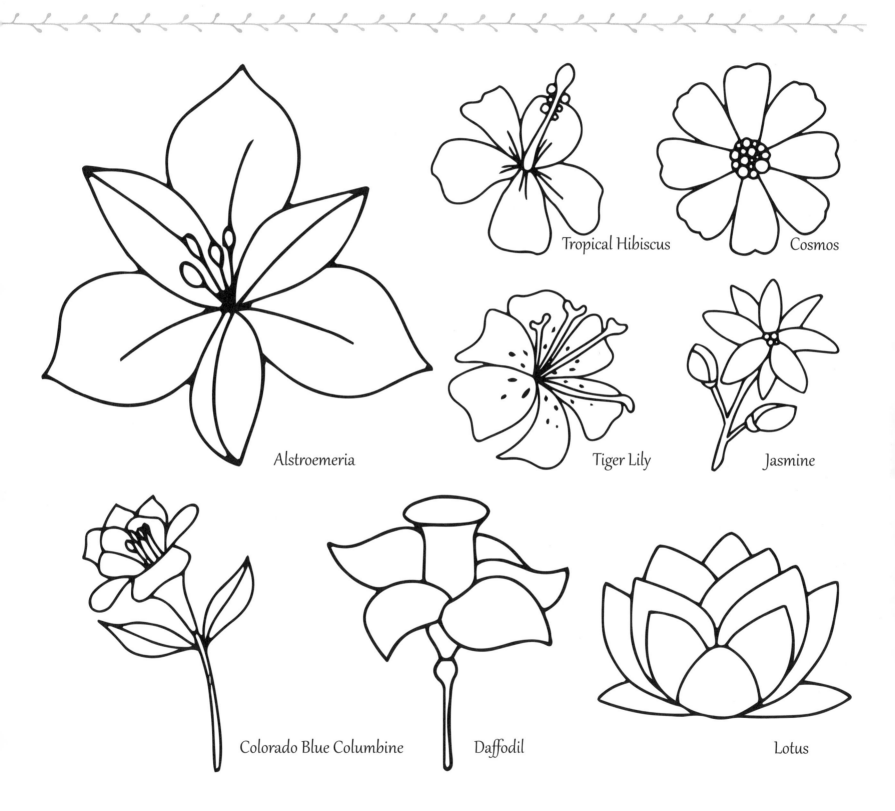

Tropical Hibiscus

Cosmos

Alstroemeria

Tiger Lily

Jasmine

Colorado Blue Columbine

Daffodil

Lotus

15

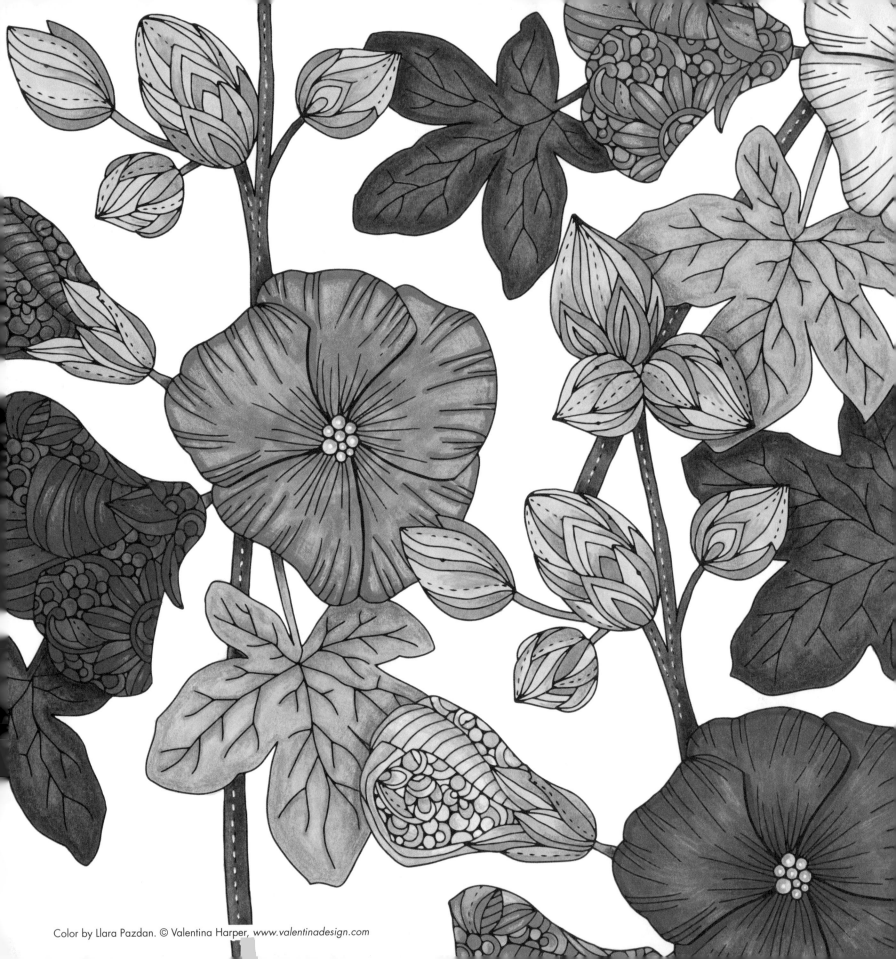

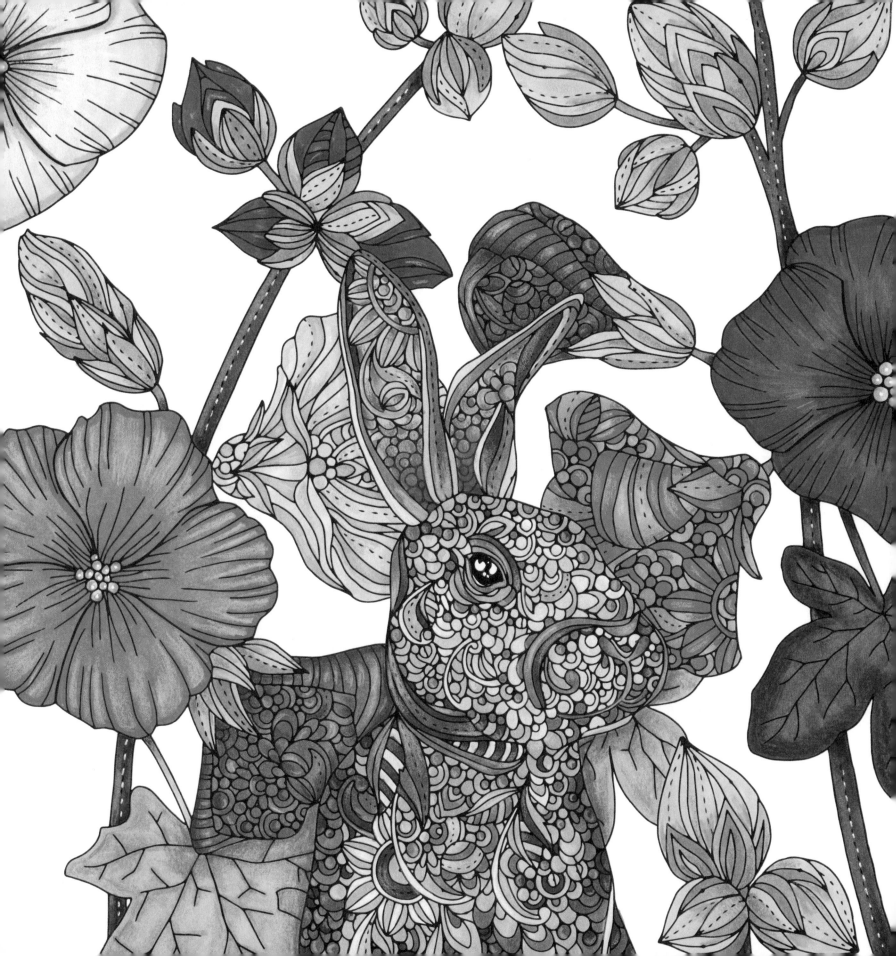

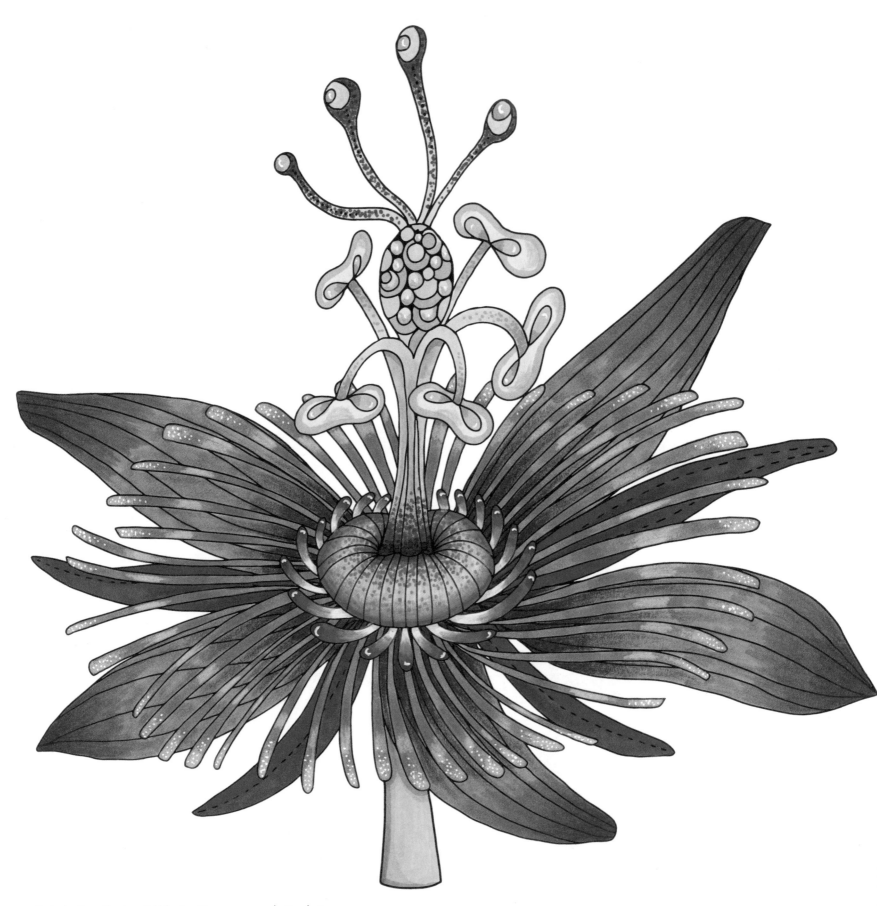

18

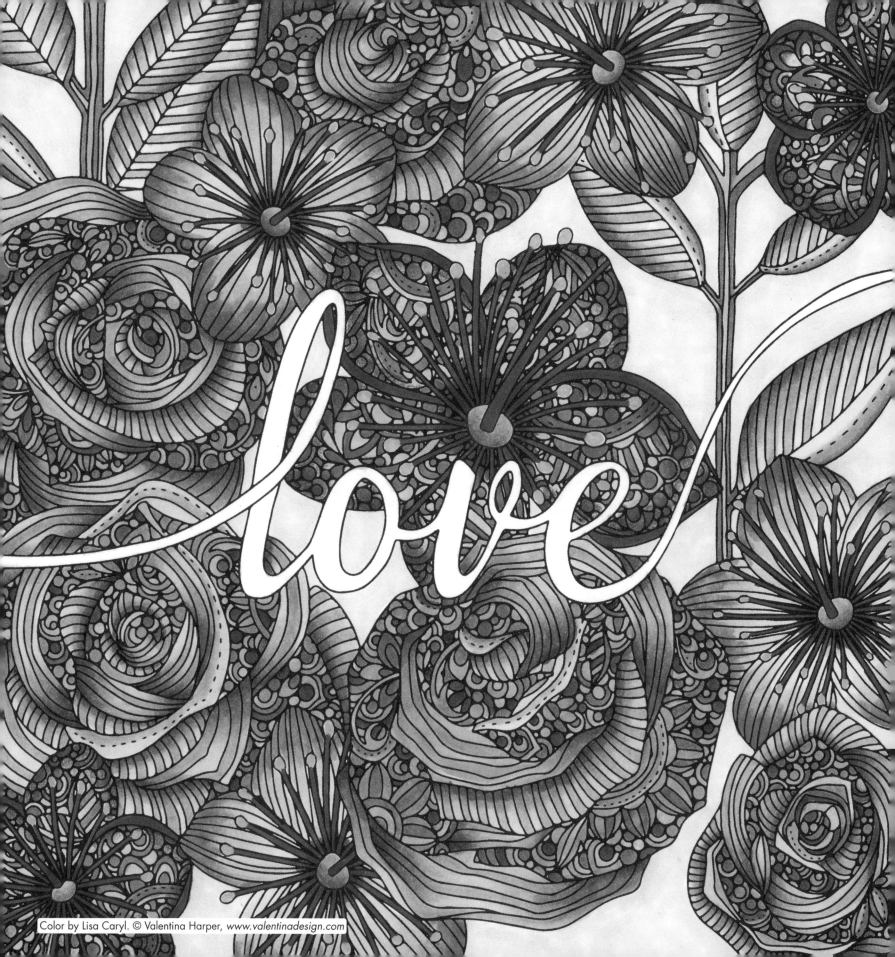

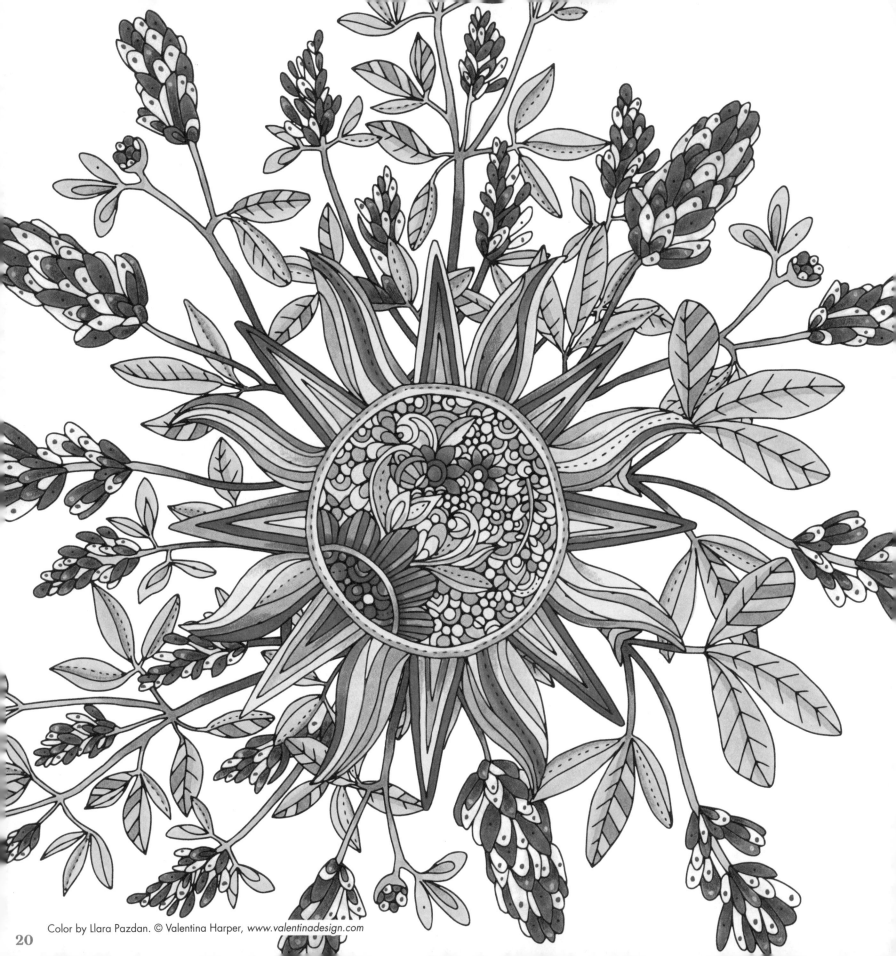

20

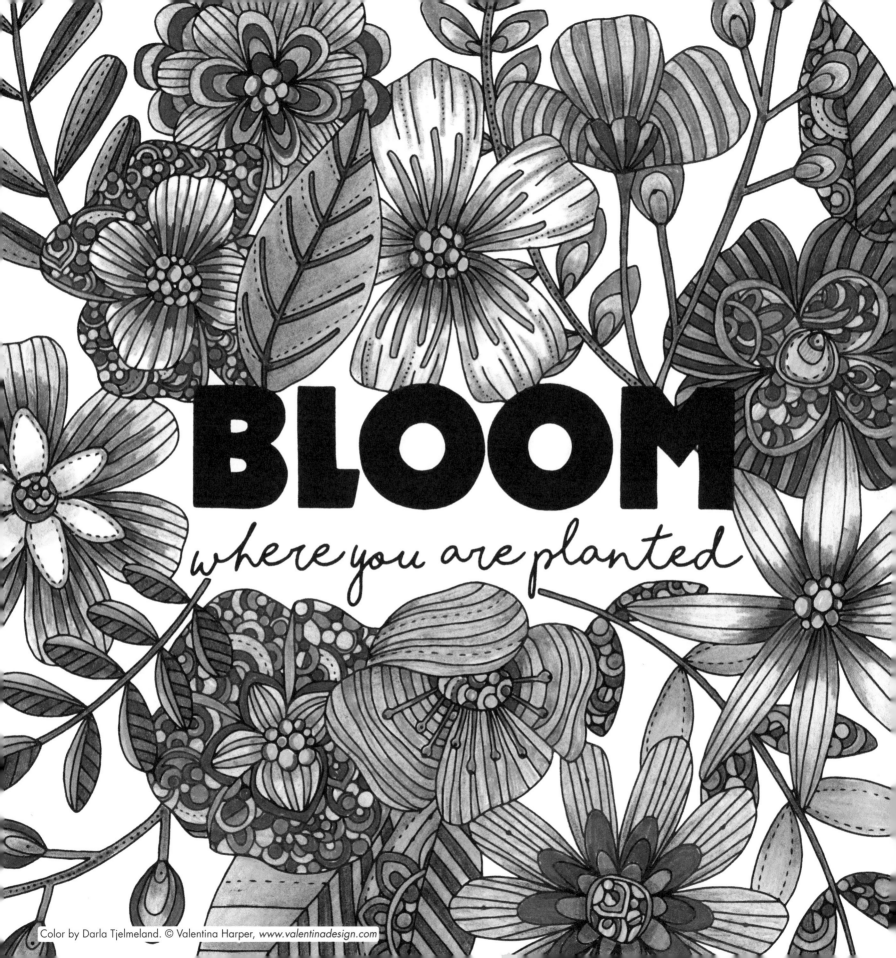

BLOOM

where you are planted

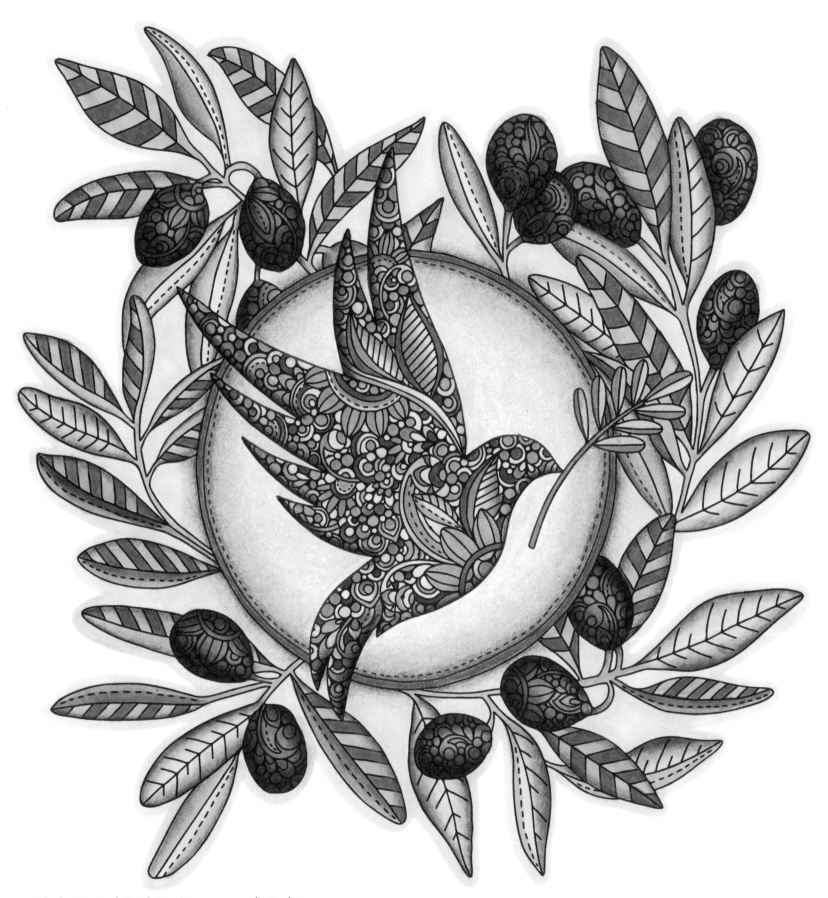

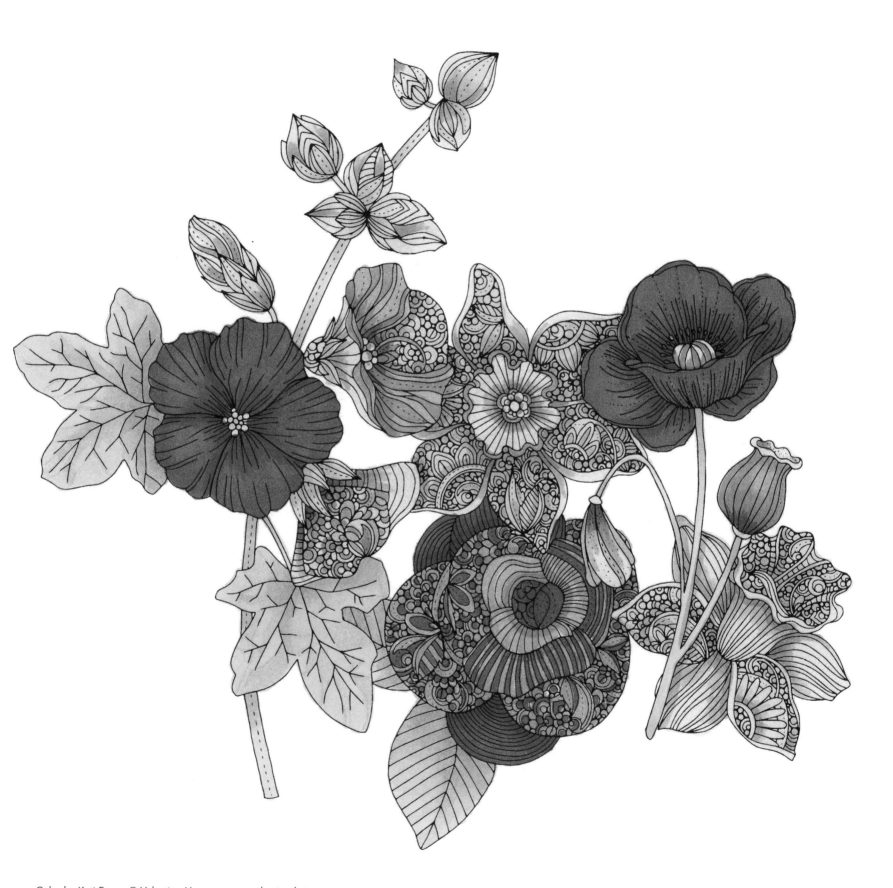

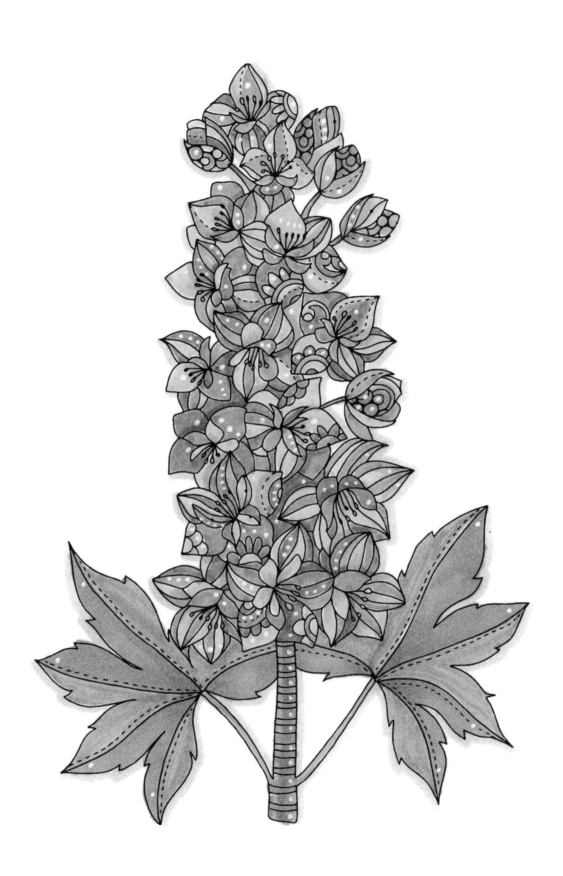

24

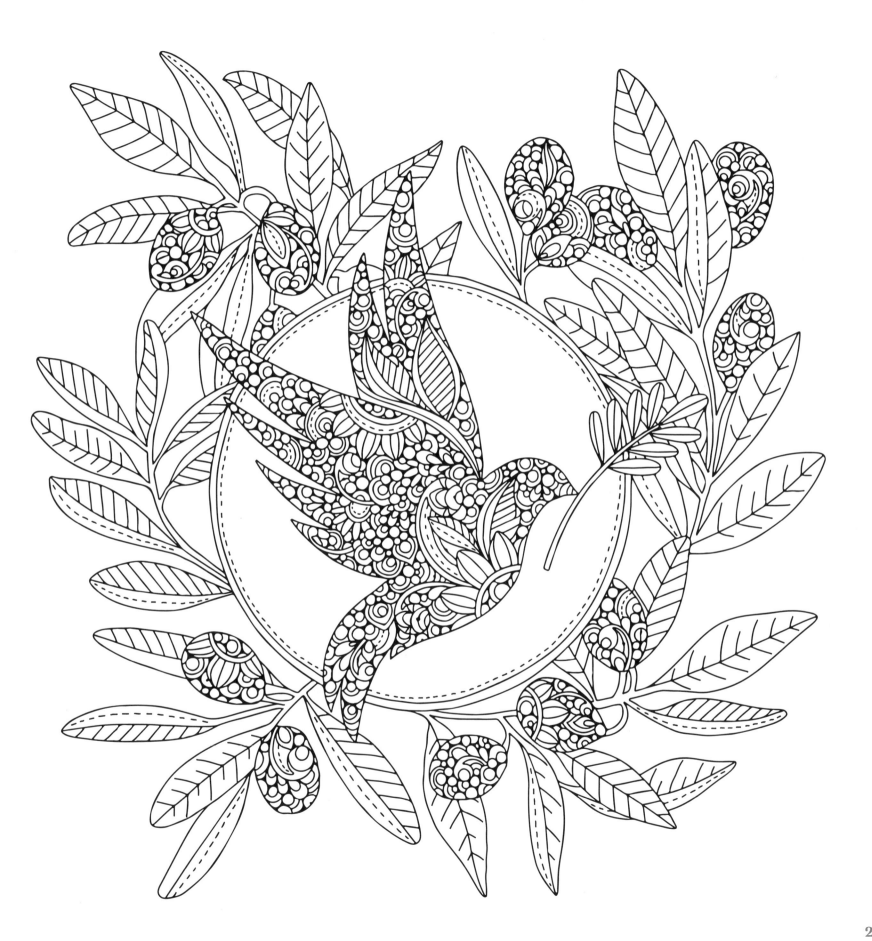

TIGER LILY

Wealth

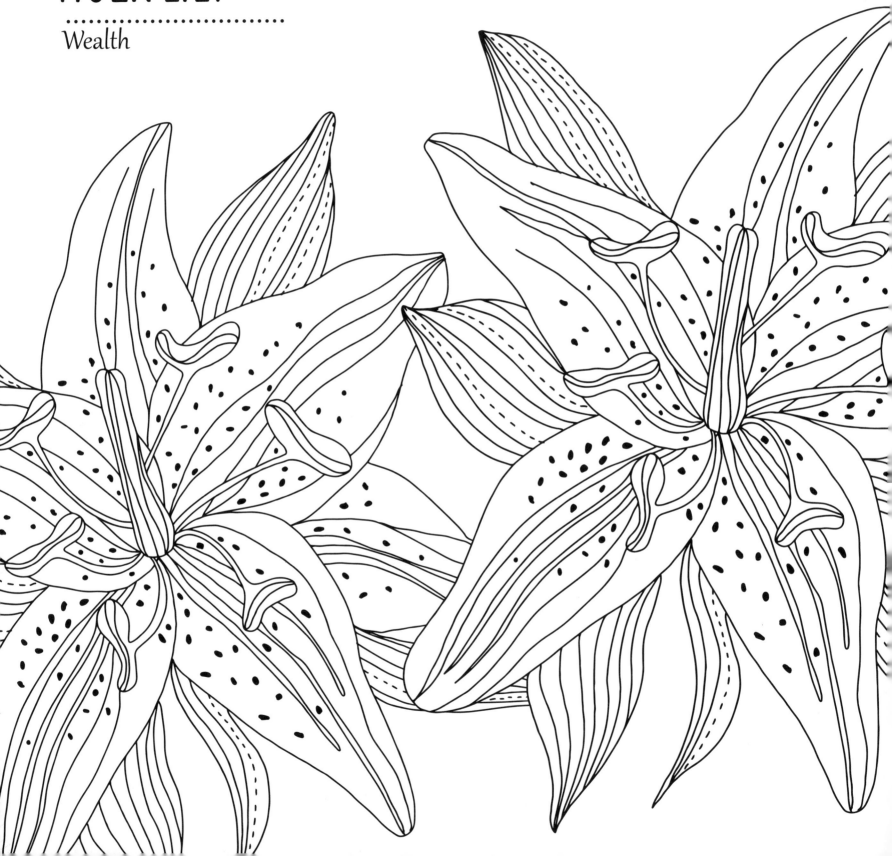

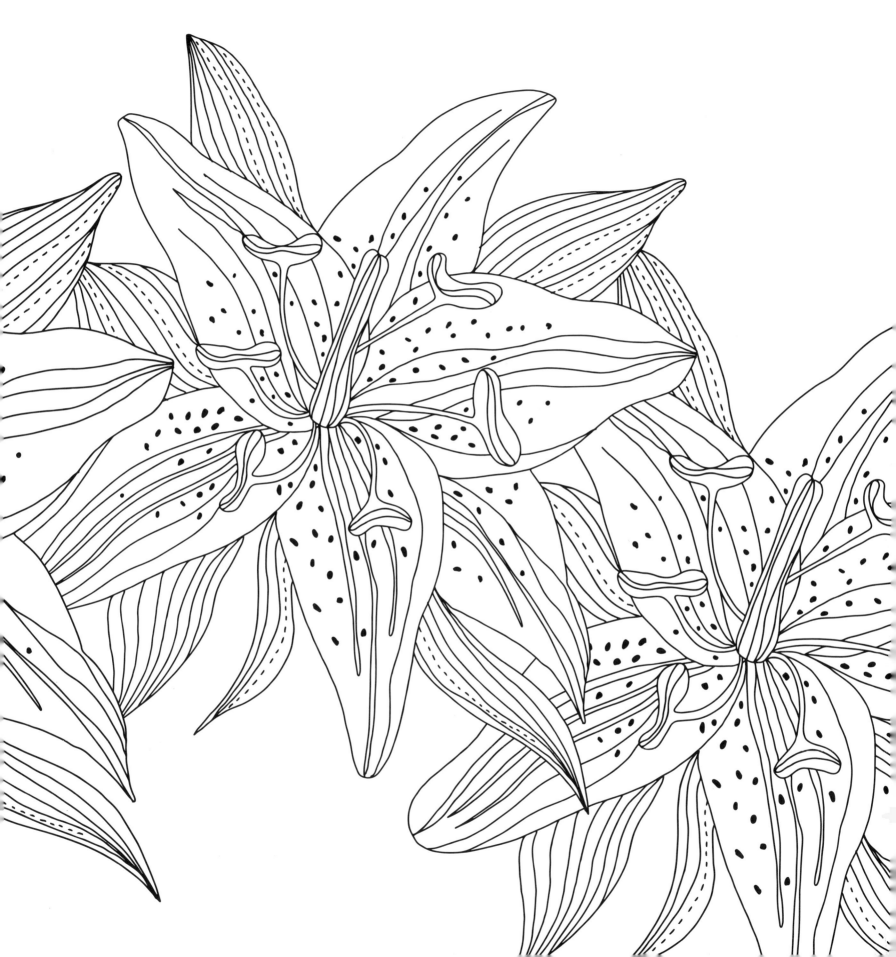

FILL UP THESE PAGES WITH FLOWERS

Select flowers from the samples on pages 12–15, and practice drawing them here, step by step. Then color them as you please.

Example: Plumeria

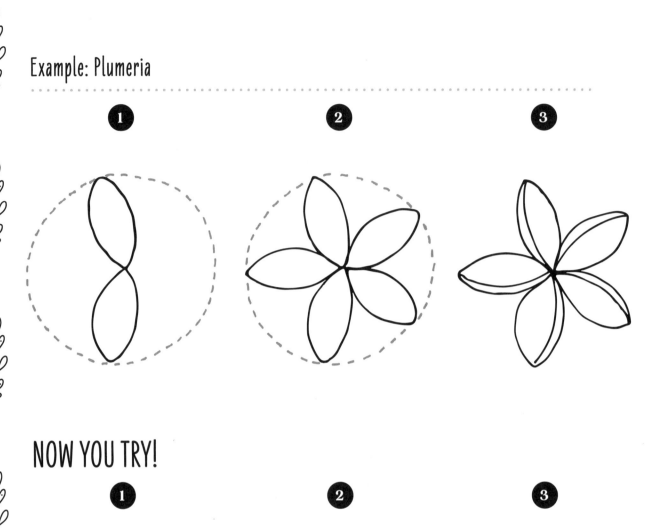

1 **2** **3**

NOW YOU TRY!

1 **2** **3**

Now try drawing flower samples from pages 12–15 in two or three steps.

Flower:

1 **2** **3**

Flower:

1 **2** **3**

DAFFODIL

Rebirth and new beginnings

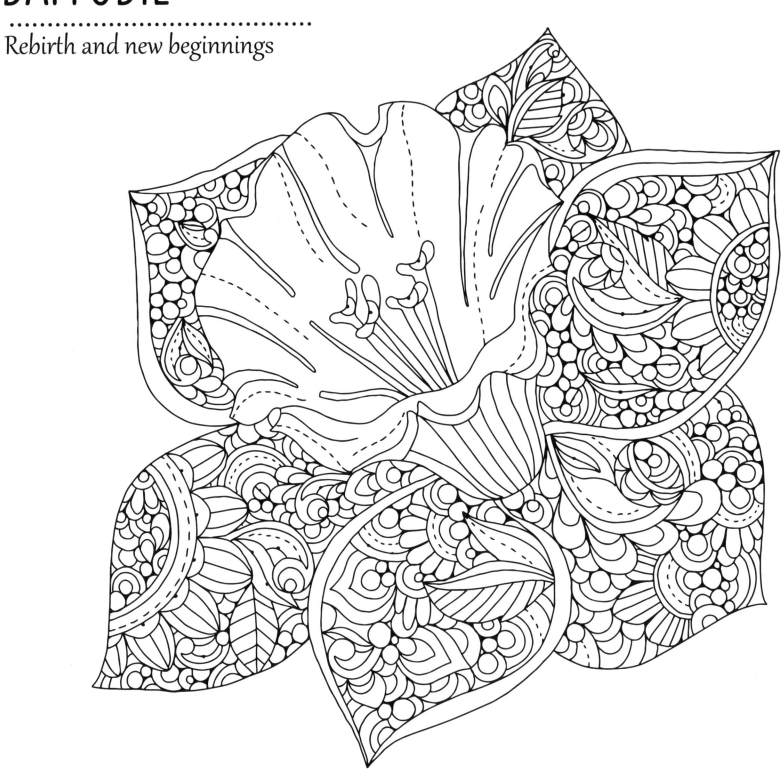

What will you grow in your garden?

..

..

..

Draw and color two flowers from pages 12–15

Flowers That Attract Butterflies

Phlox · Coneflower · Lantana · Bluestar · Pot Marigolds · Black-Eyed Susan
Blazing Star Flowers · Heliotrope · Lavender · Aster · Sunflowers

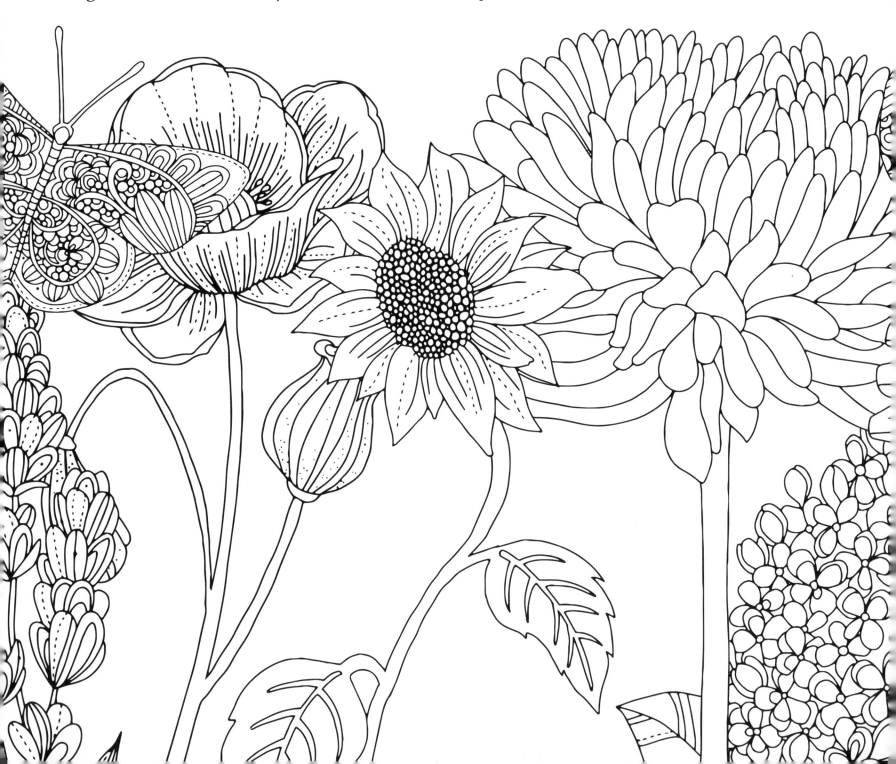

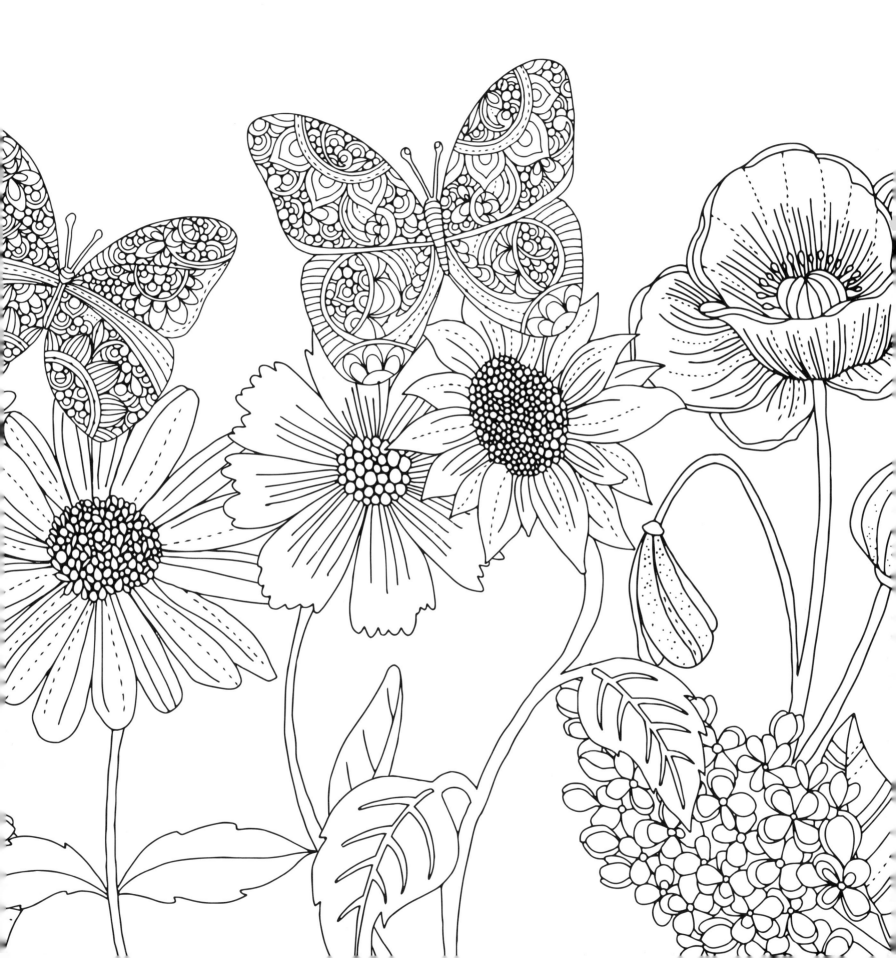

CACTUS FLOWER

Maternal love

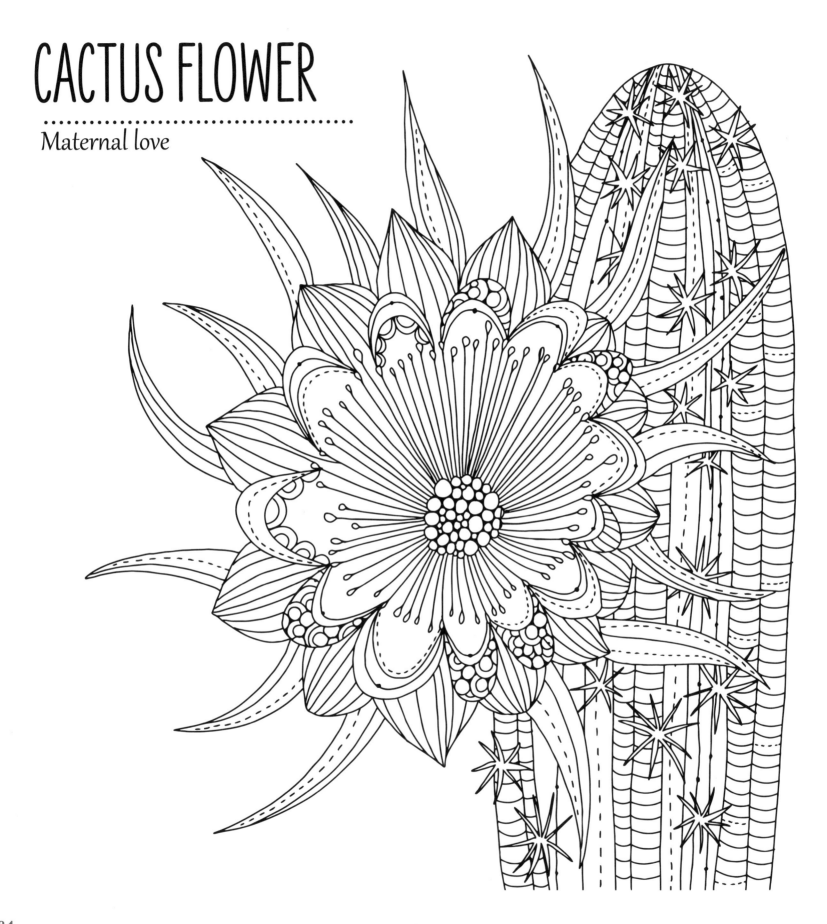

Fill these petals with your own designs! Check the patterns on pages 8–11 for ideas.

Be like the lotus: trust in the light, grow through the dirt, believe in new beginnings.

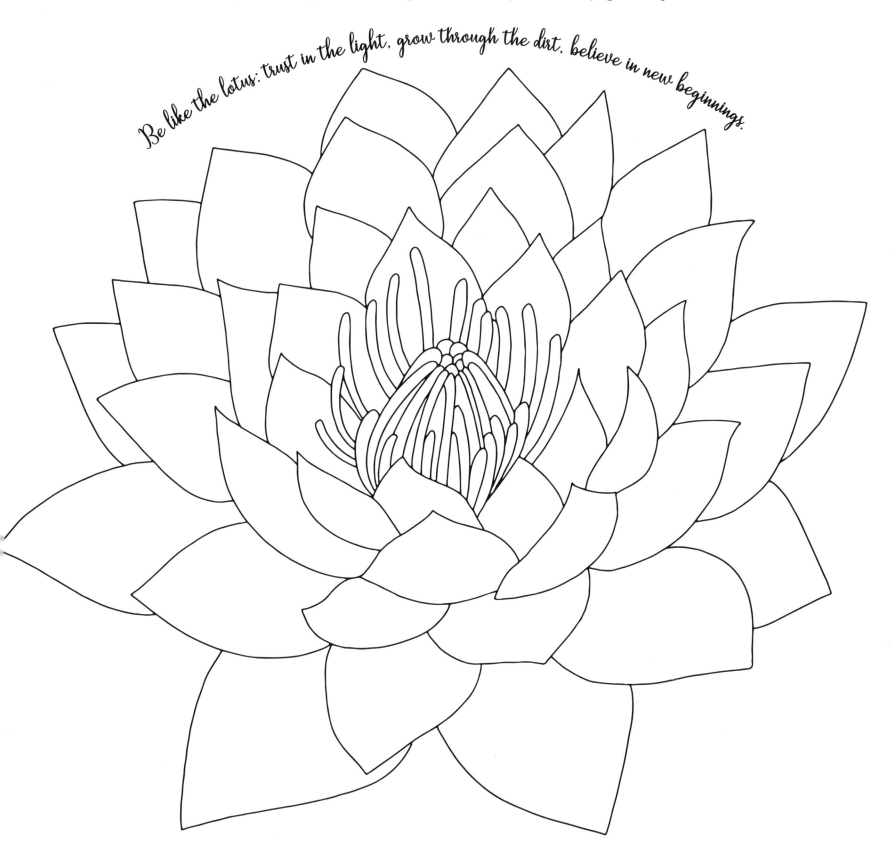

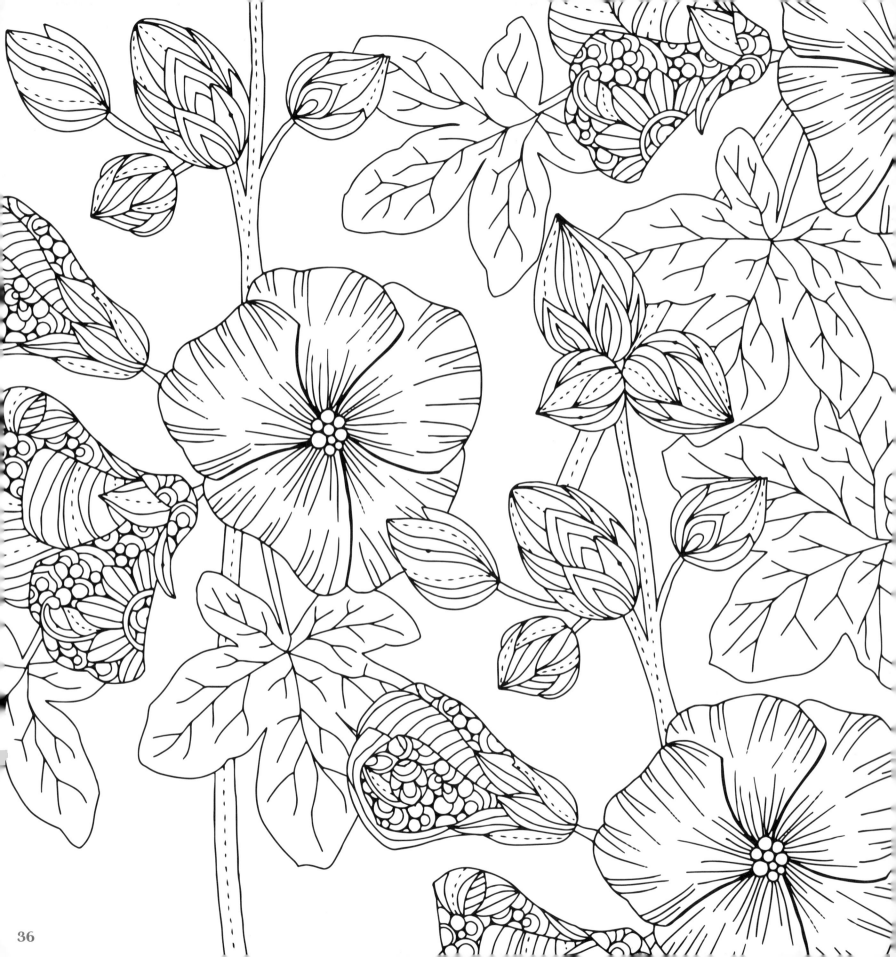

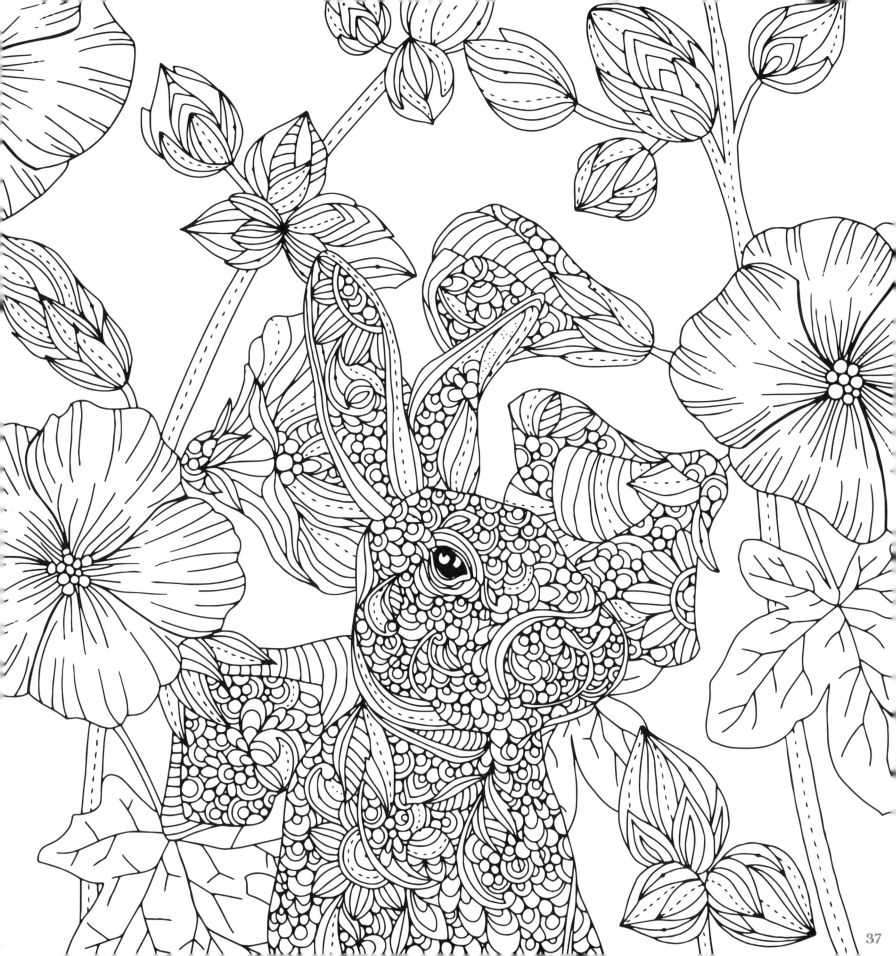

WHAT WILL
YOU PLANT
NEXT SPRING?

ANEMONE

Protection and anticipation

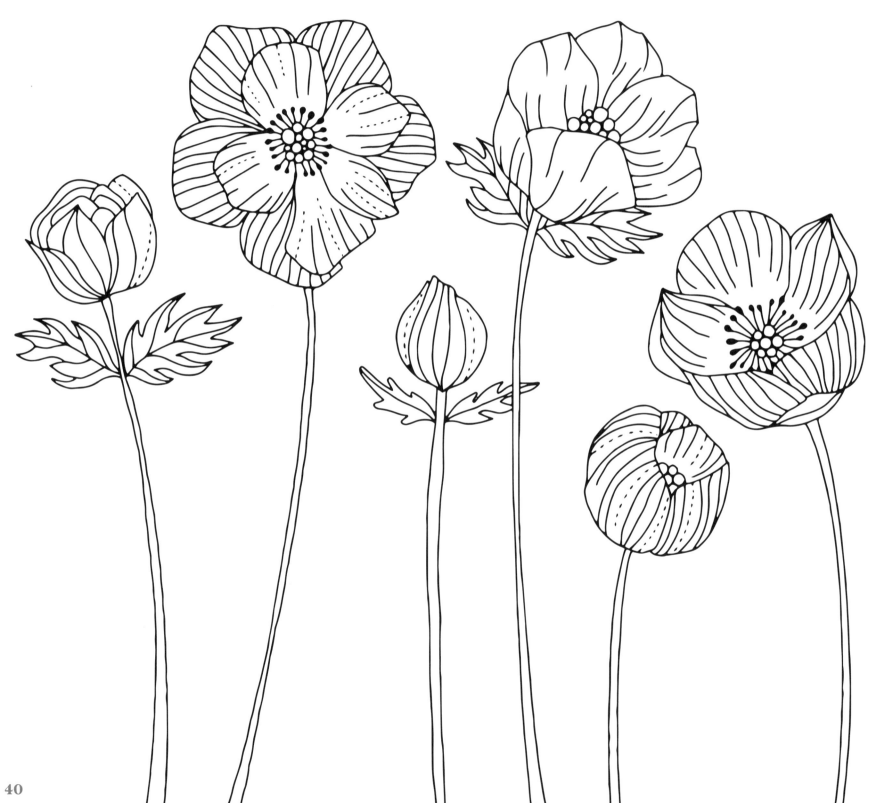

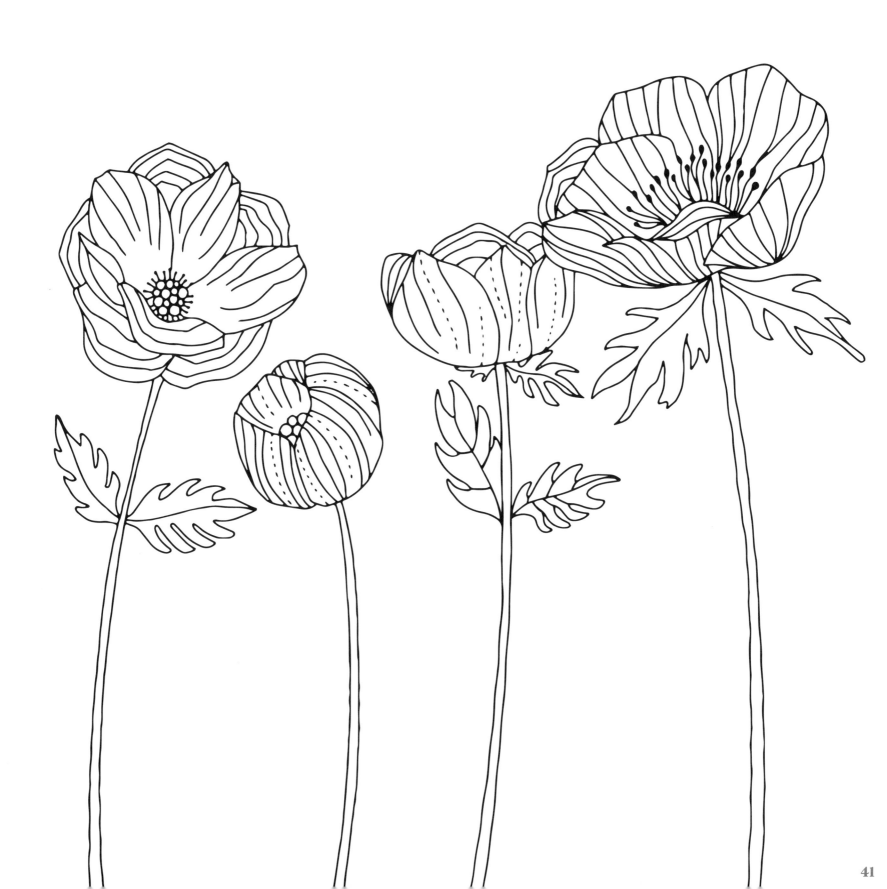

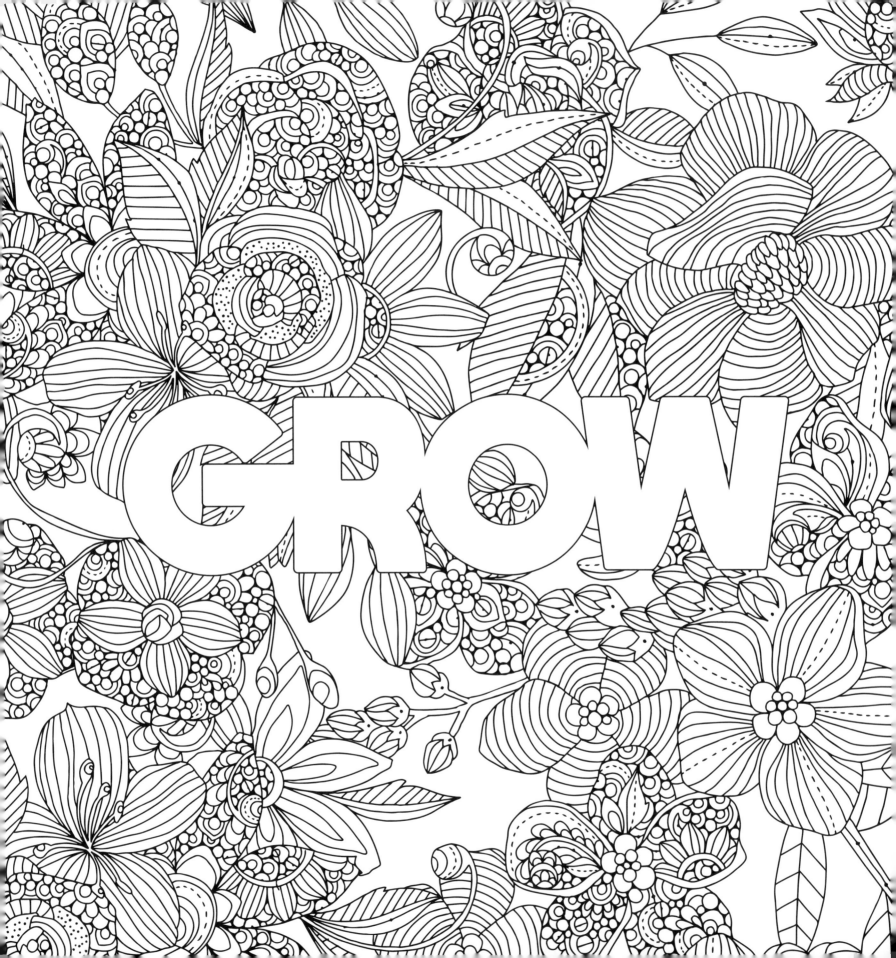

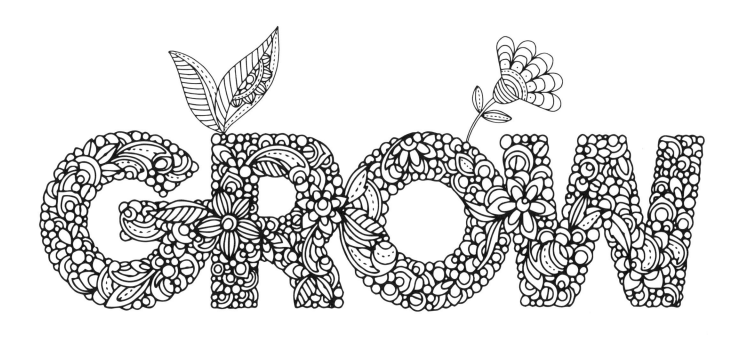

"To nurture a garden is to feed not just the body but the soul."
—Alfred Austin

Peace

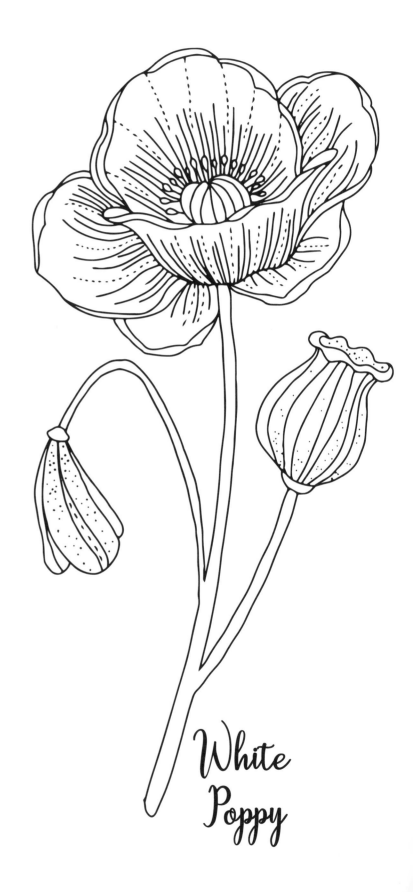

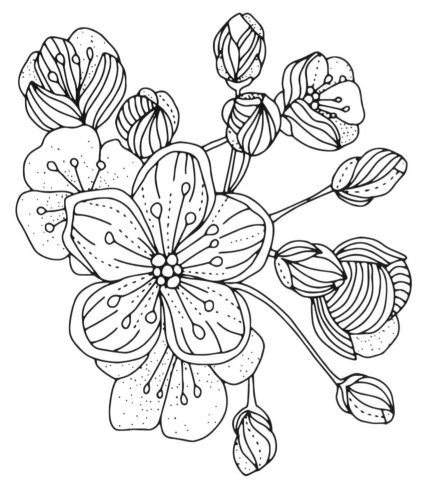

Apple Blossom

White
Poppy

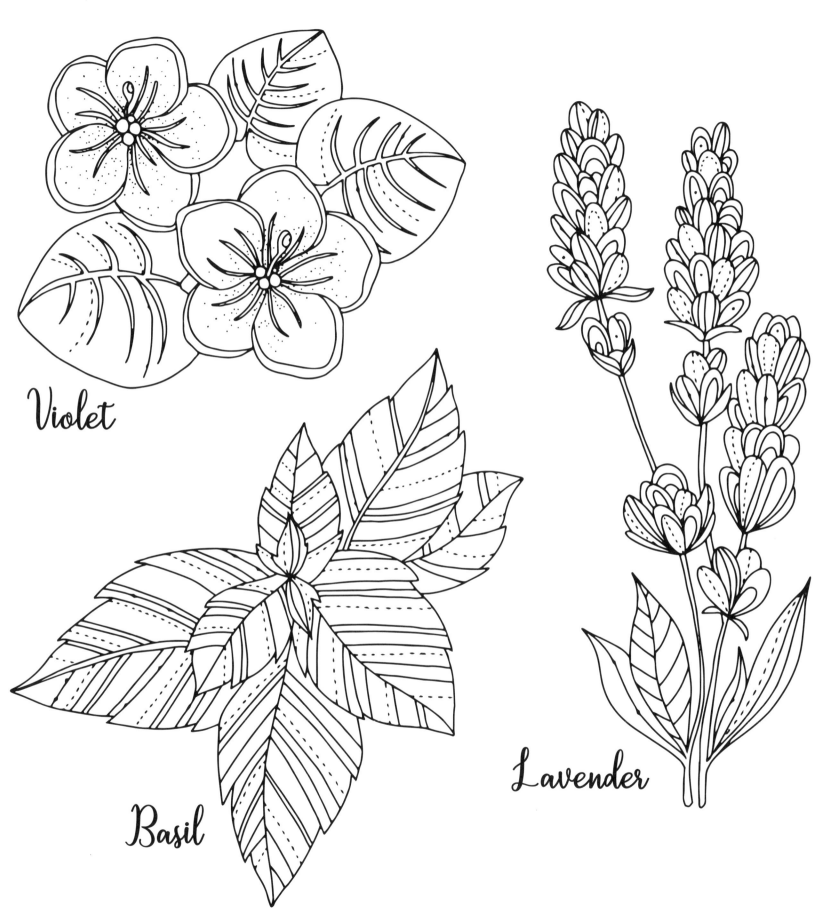

Violet

Basil

Lavender

45

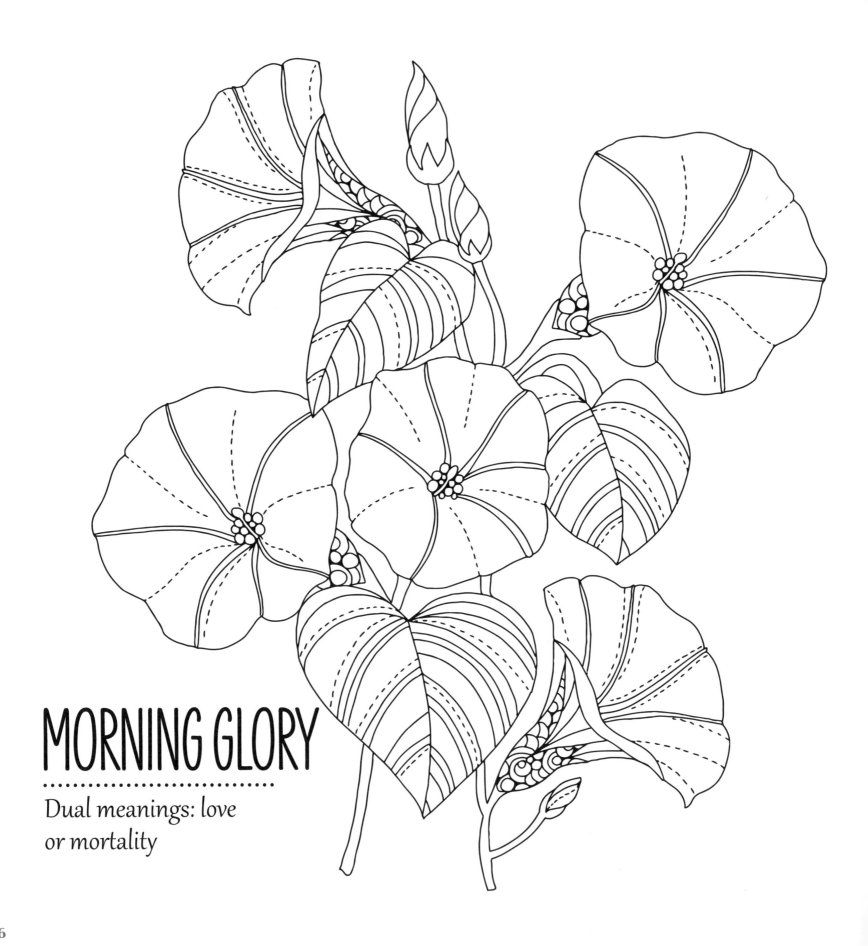

MORNING GLORY

Dual meanings: love
or mortality

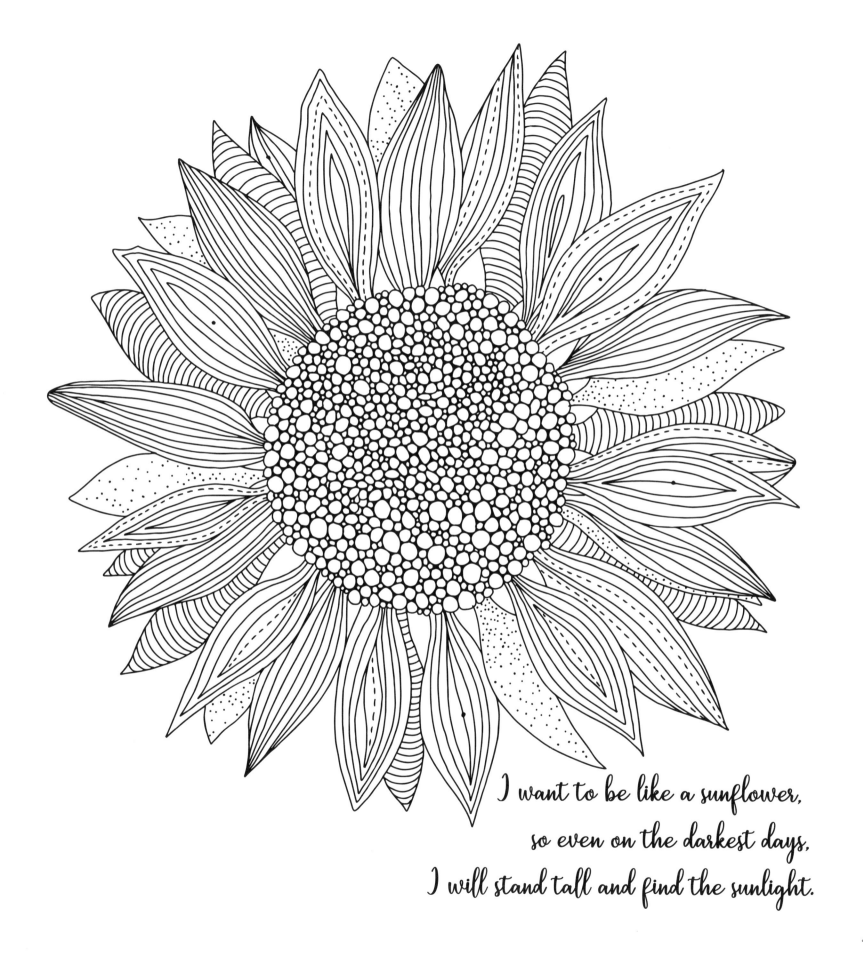

I want to be like a sunflower,
so even on the darkest days,
I will stand tall and find the sunlight.

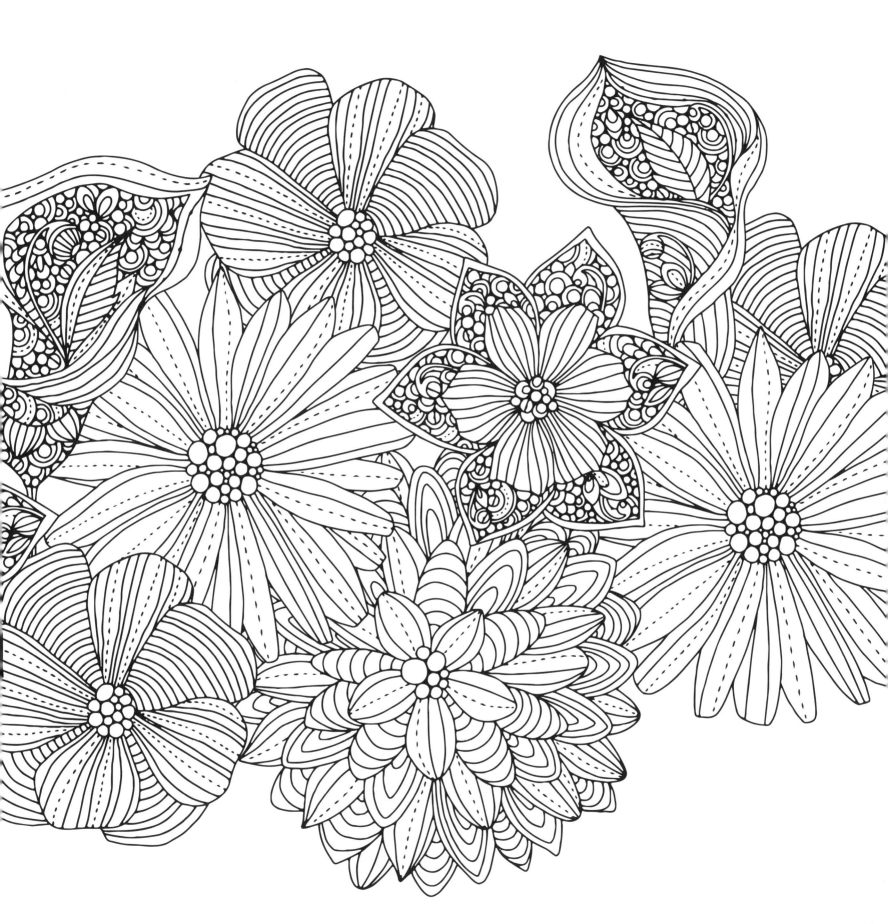

PINCUSHION FLOWER

Love, purity, and peace

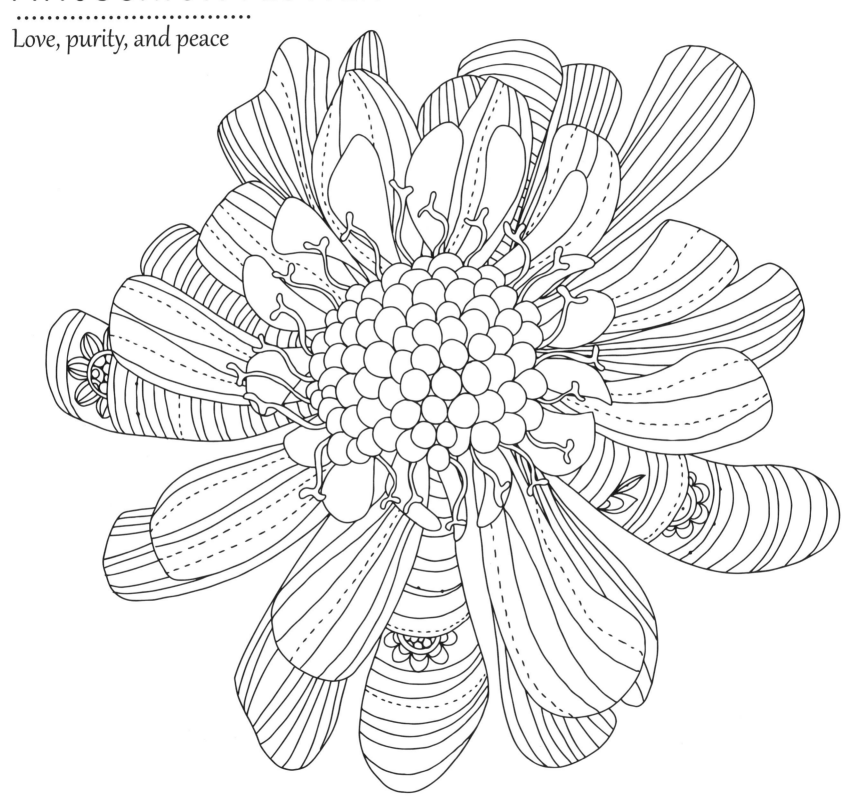

Some see a weed

Some see a wish

Make a wish

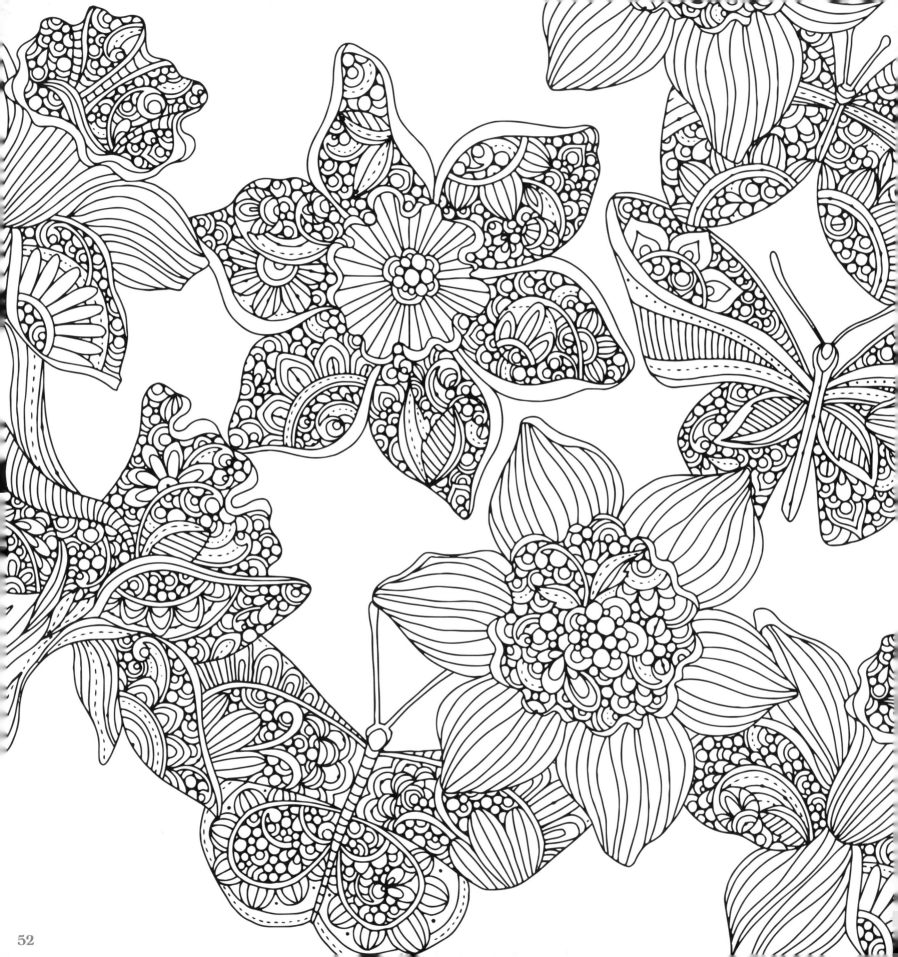

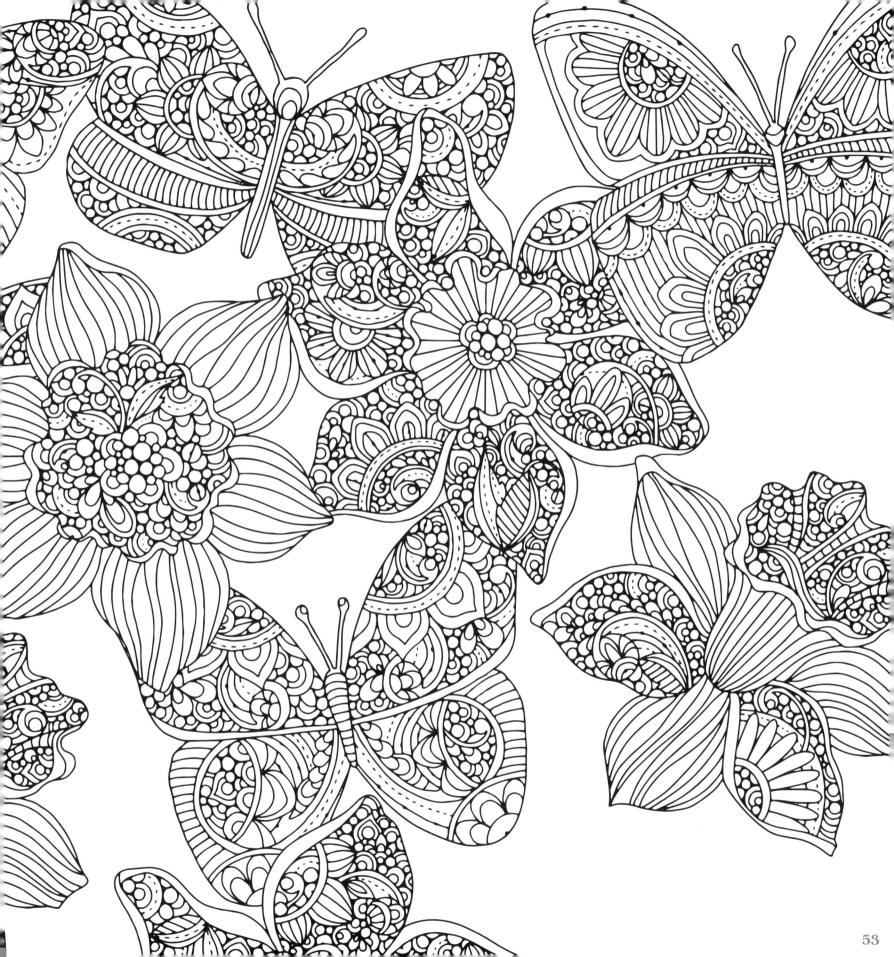

What will you plant next summer?

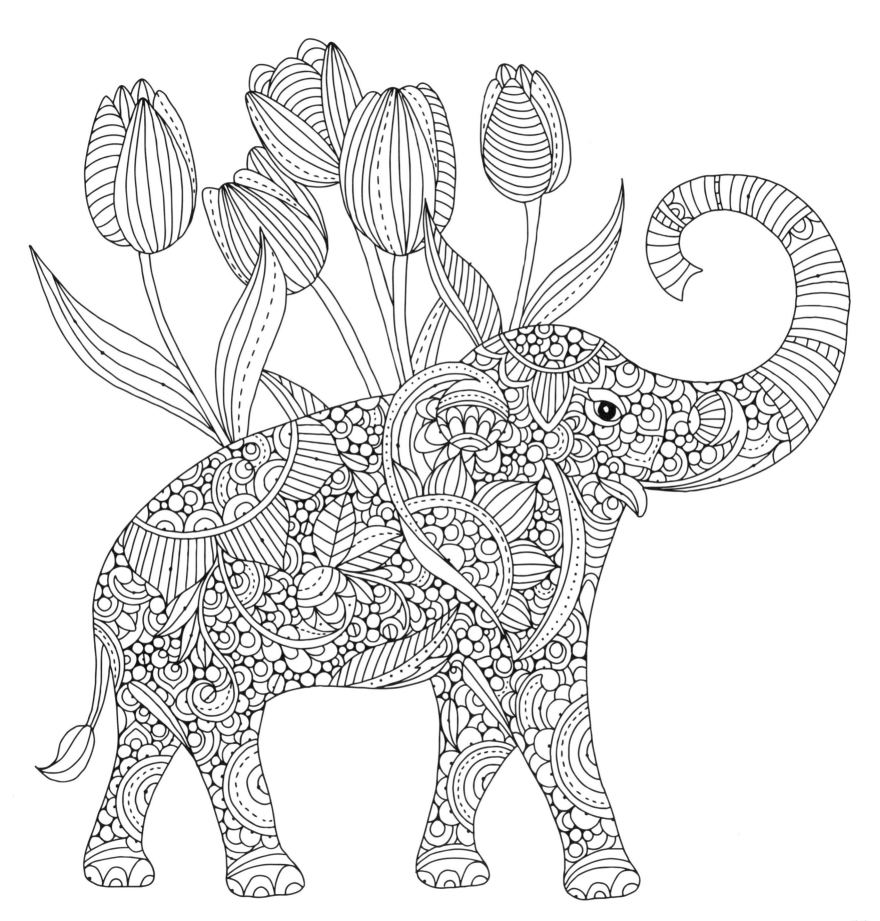

WILD GERANIUM (cranesbill)

Friendship, happiness, and positive emotions

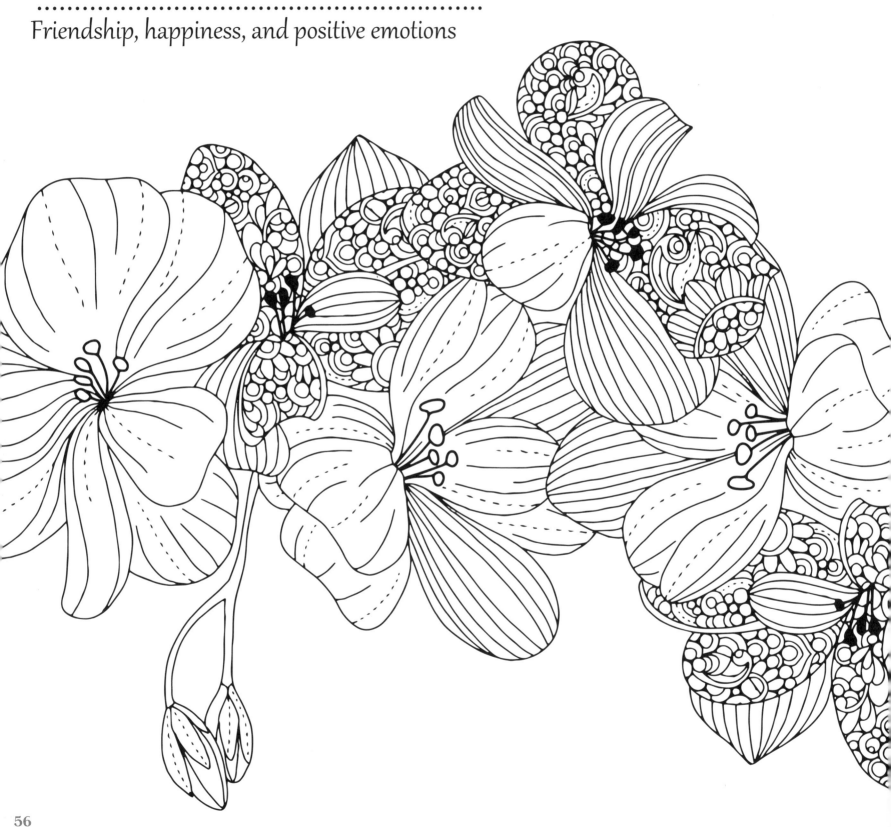

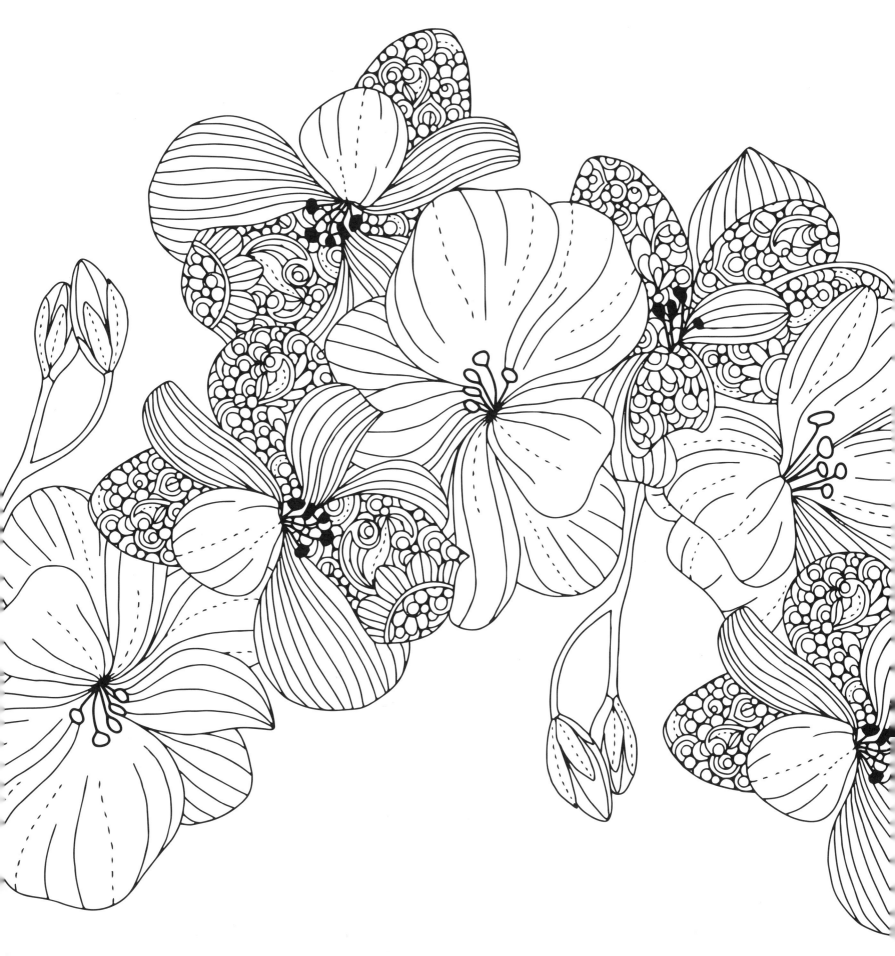

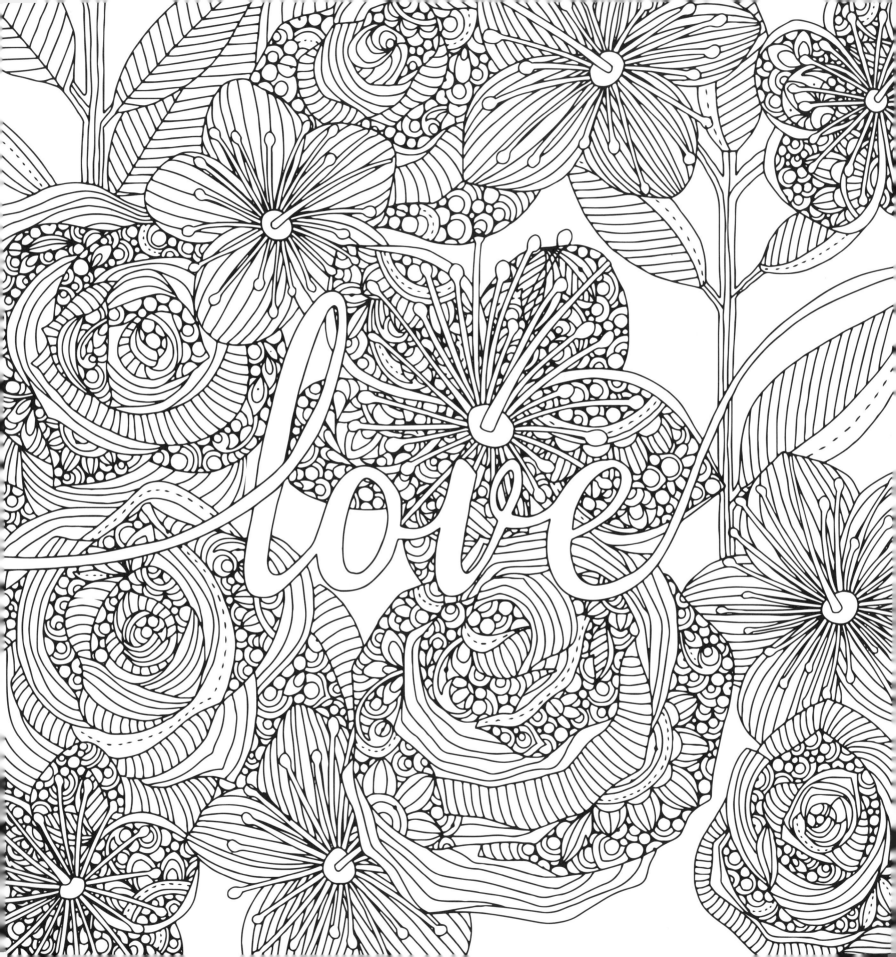

PANAMA ROSE

Endurance

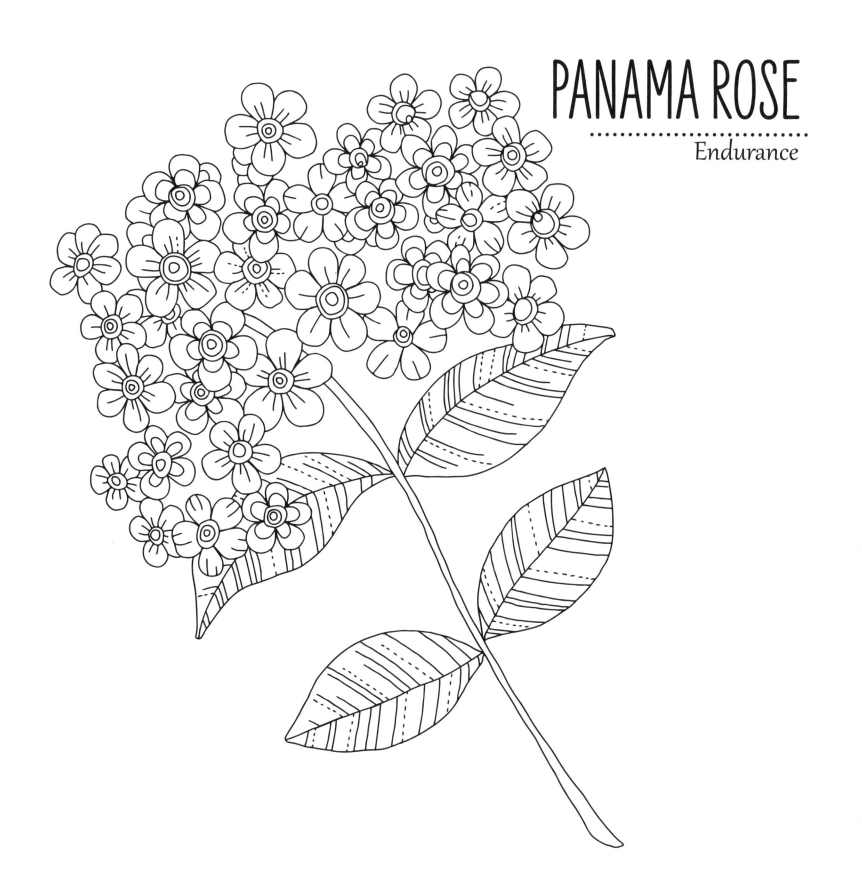

Fill these flowers and leaves with your own designs!
Try using patterns from pages 8–11 to get started.

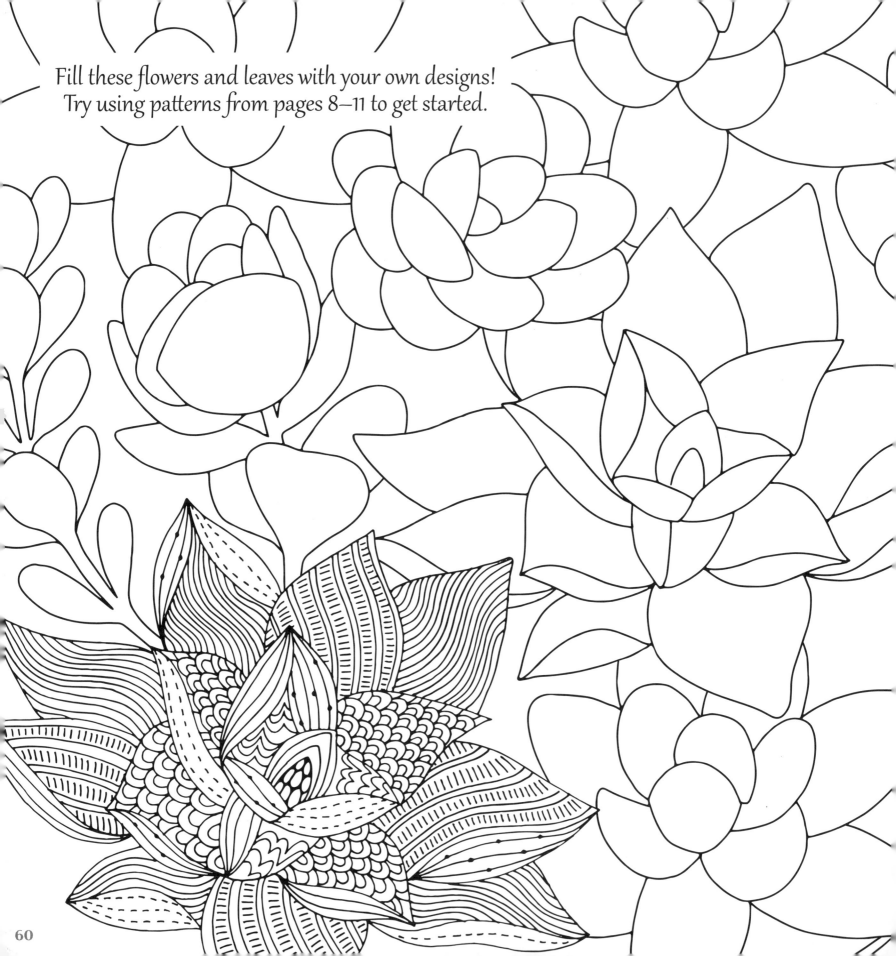

enduring and timeless love

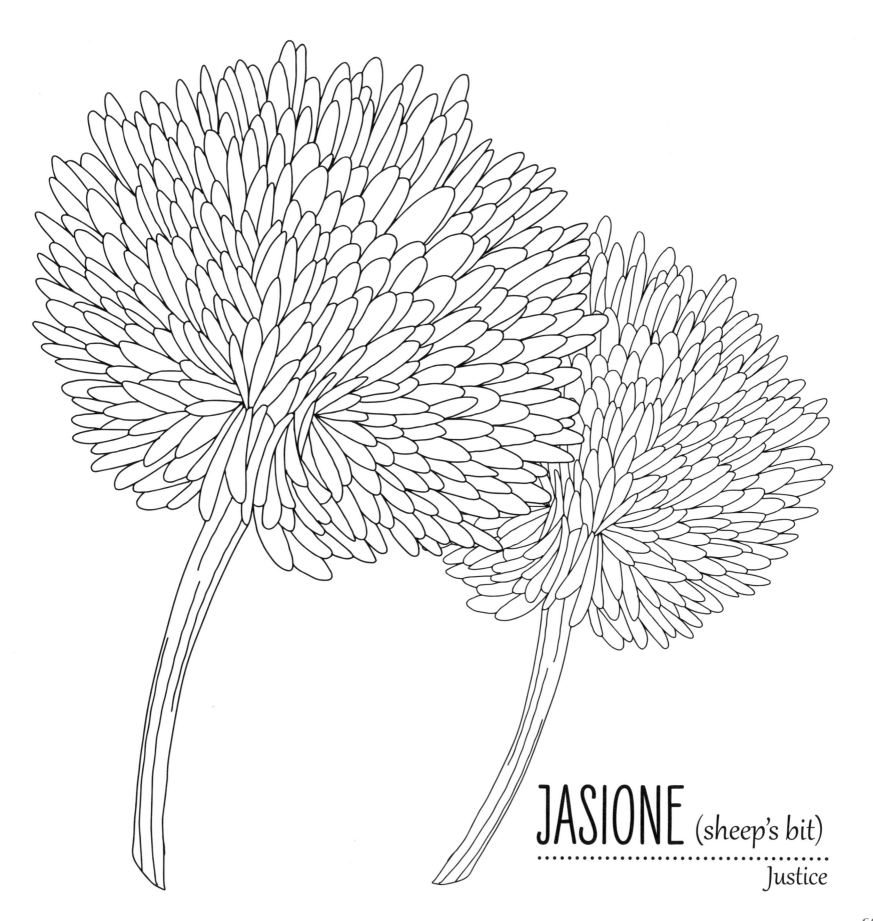

JASIONE (sheep's bit)
Justice

BEGONIA

Caution

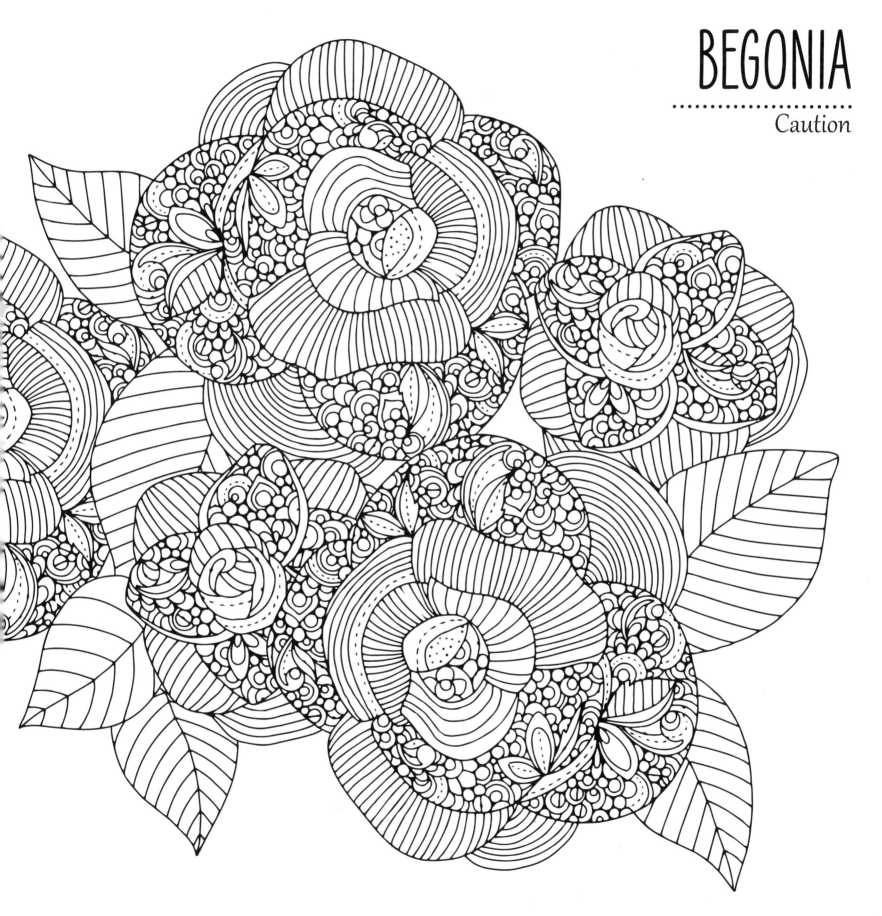

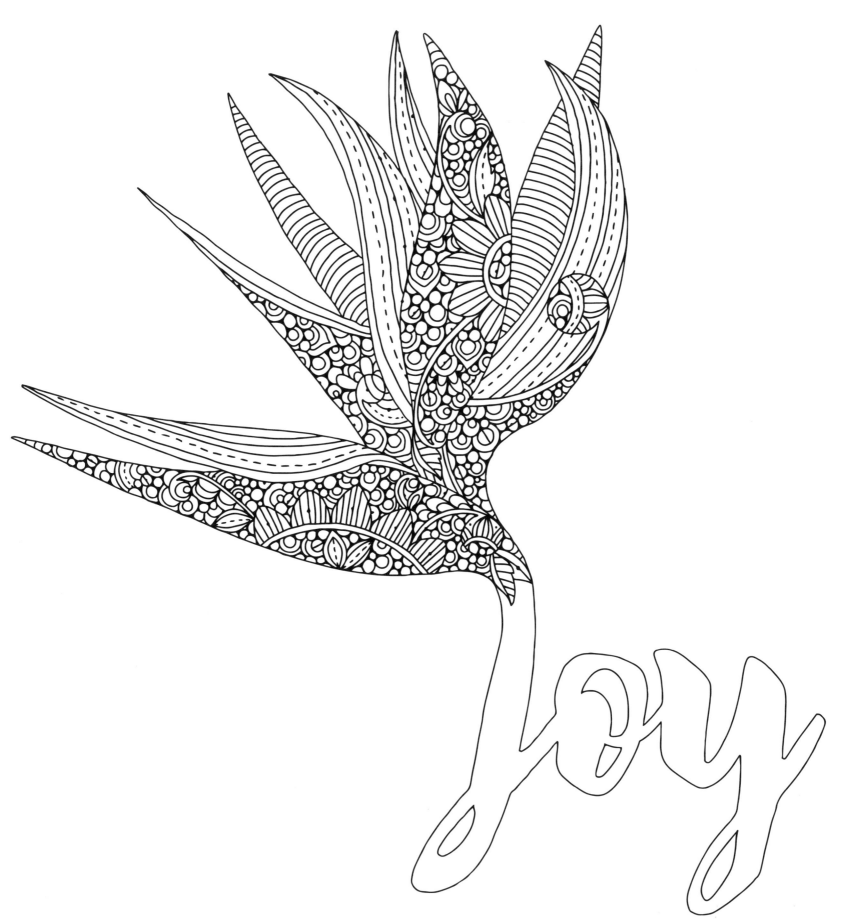

GERBERA DAISY

Cheerfulness

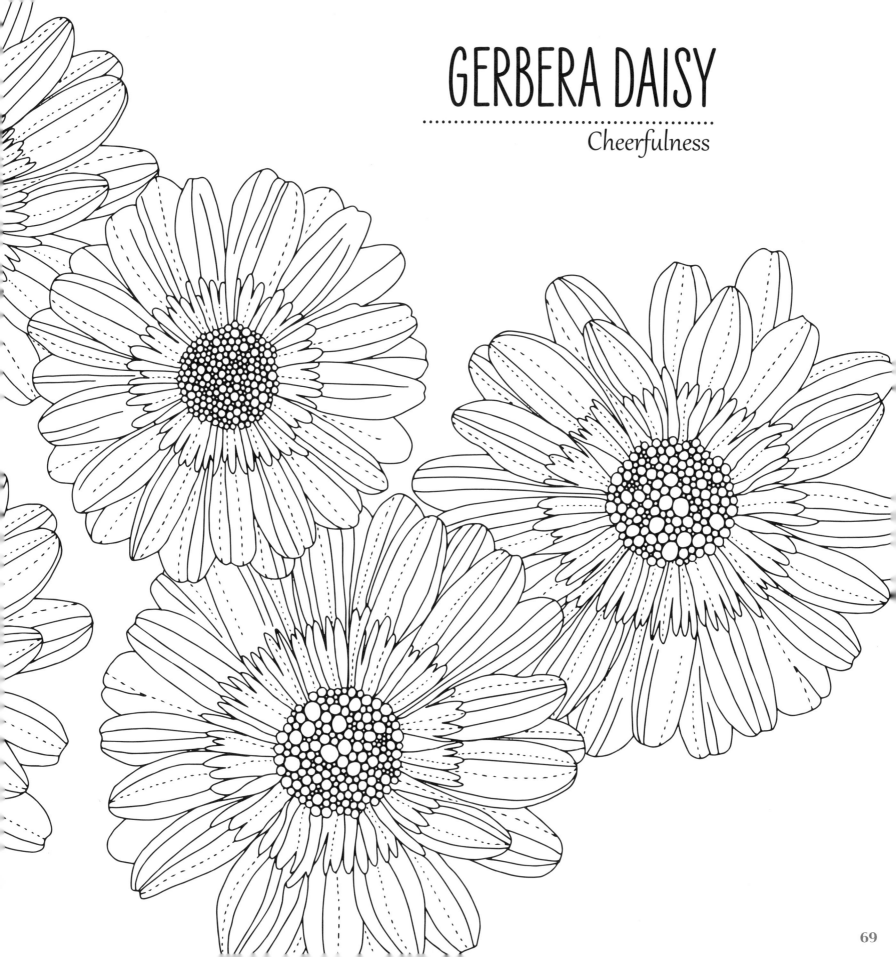

MALLOW

Love, protection, and health

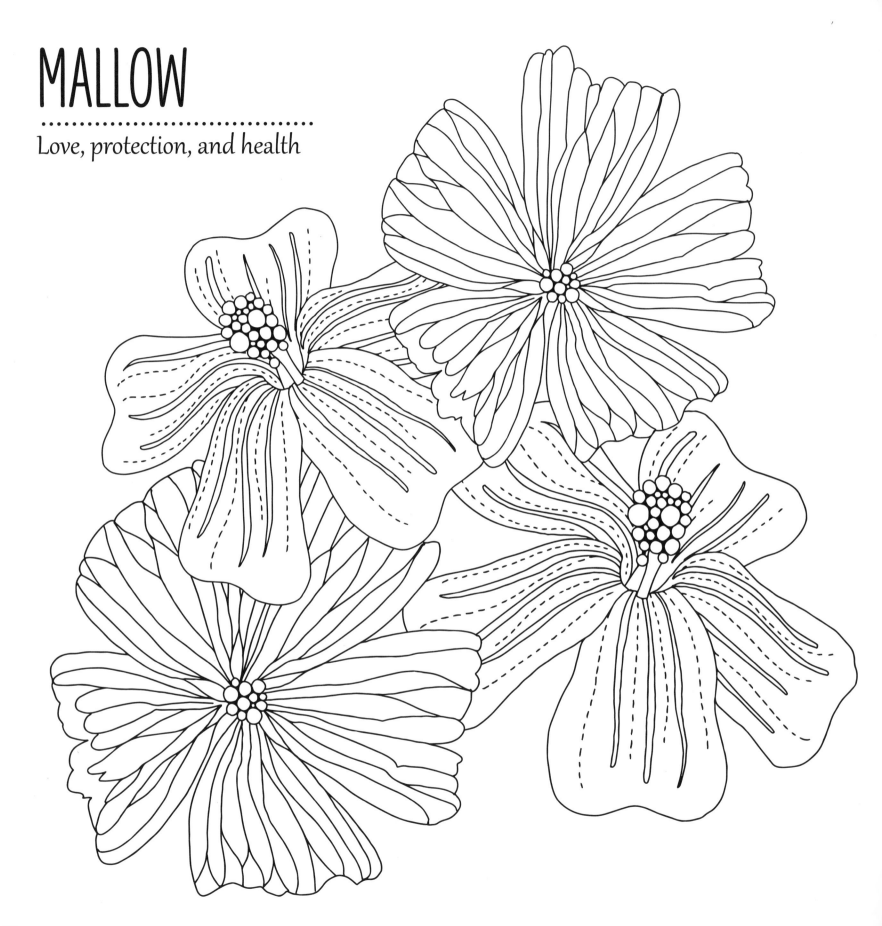

Fill with your own designs!
Try using patterns from pages 8–11 to get started.

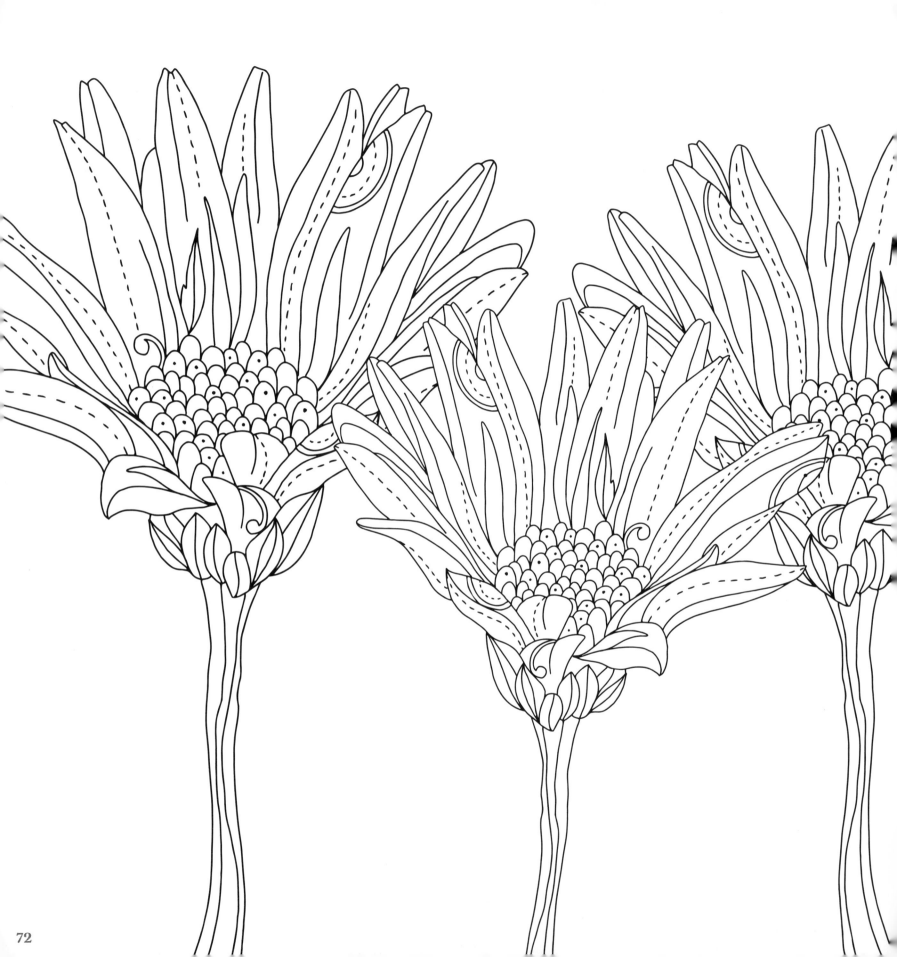

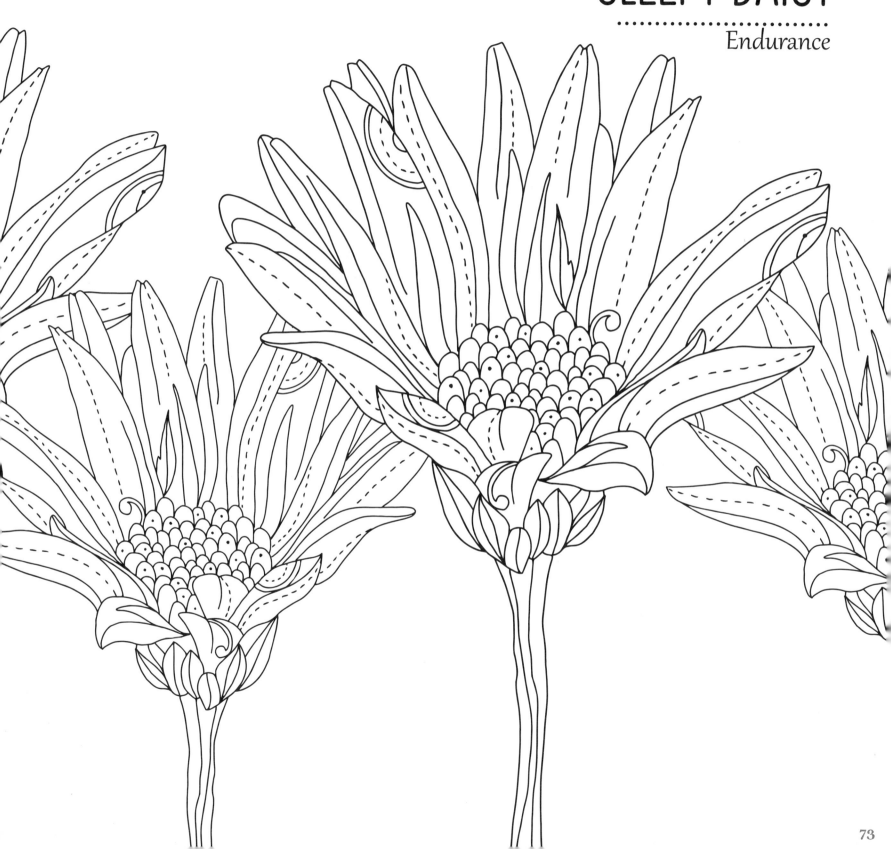

SLEEPY-DAISY

Endurance

list your favorite flowers here

HEATHER

Admiration, beauty, and good luck

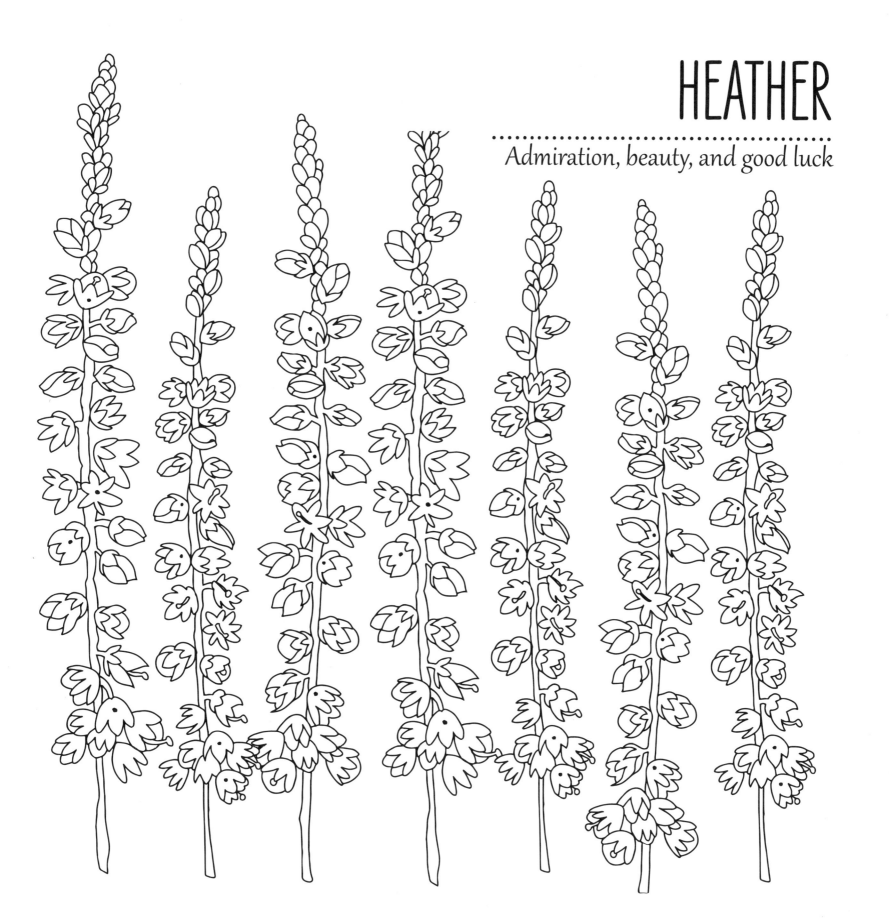

Medicinal flowers

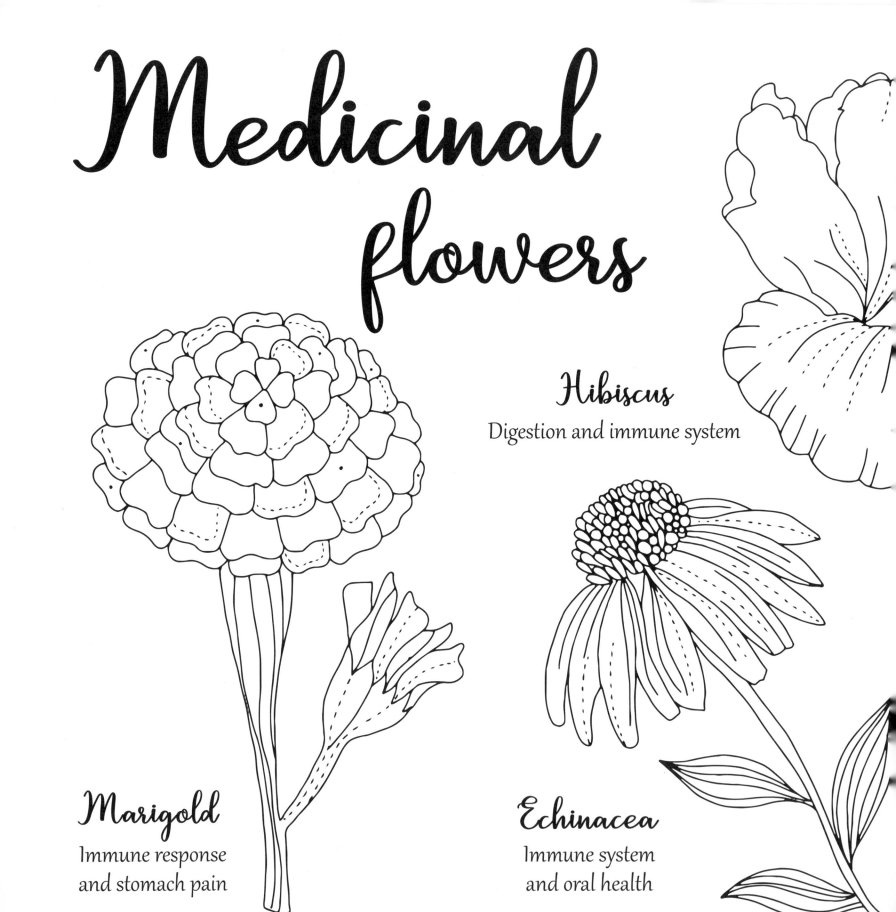

Hibiscus

Digestion and immune system

Marigold

Immune response
and stomach pain

Echinacea

Immune system
and oral health

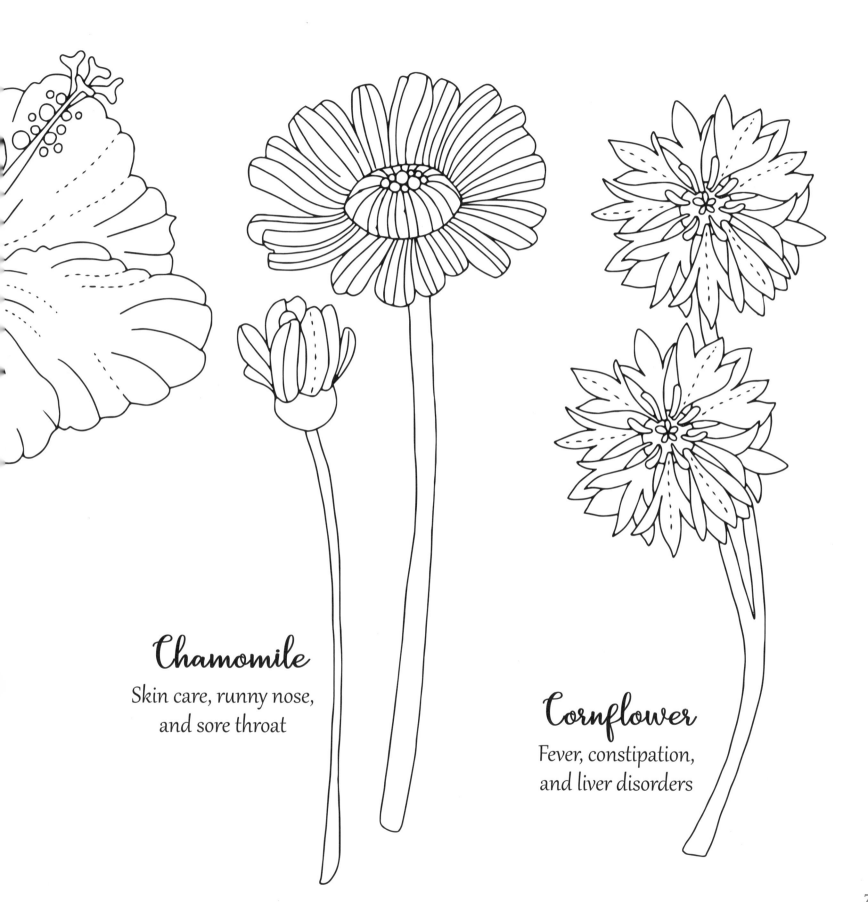

Chamomile

Skin care, runny nose,
and sore throat

Cornflower

Fever, constipation,
and liver disorders

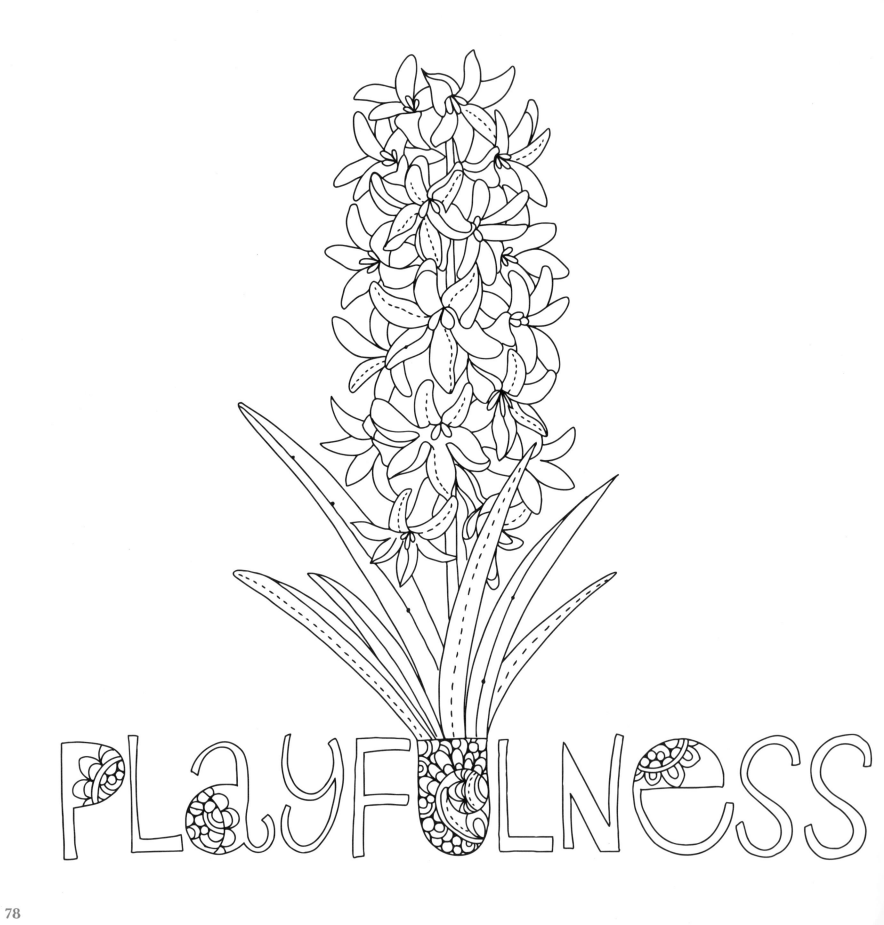

PLAYFULNESS

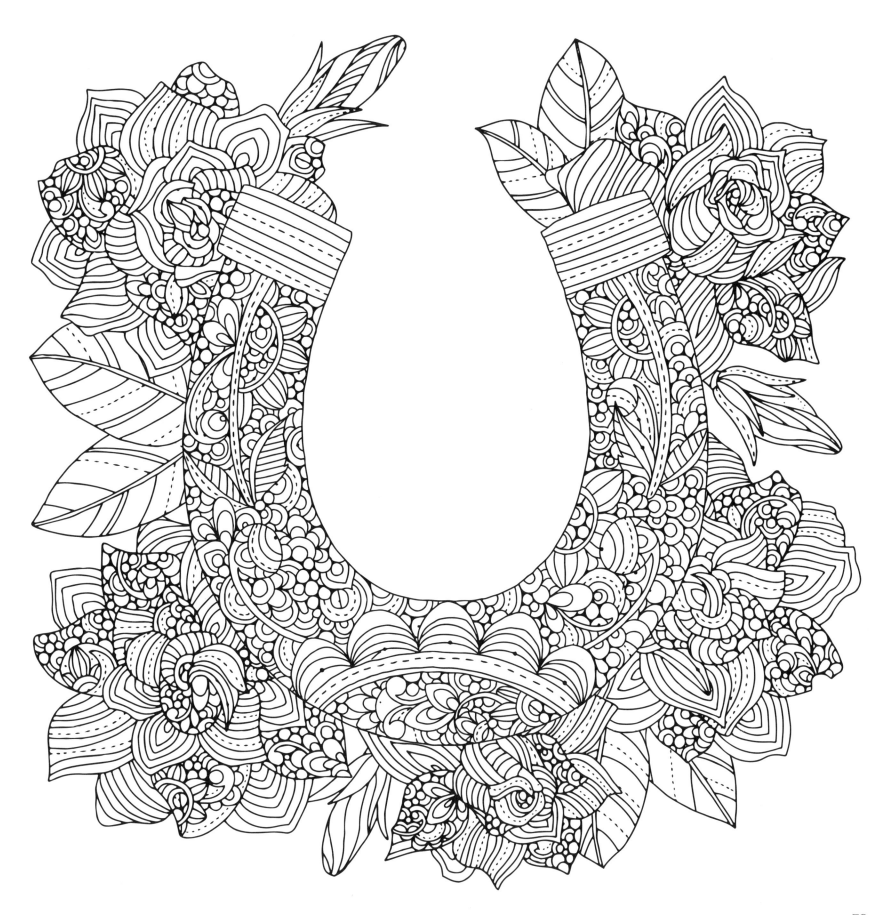

Camellias

White Innocence

Pink Romance, love, and affection

Red Passion

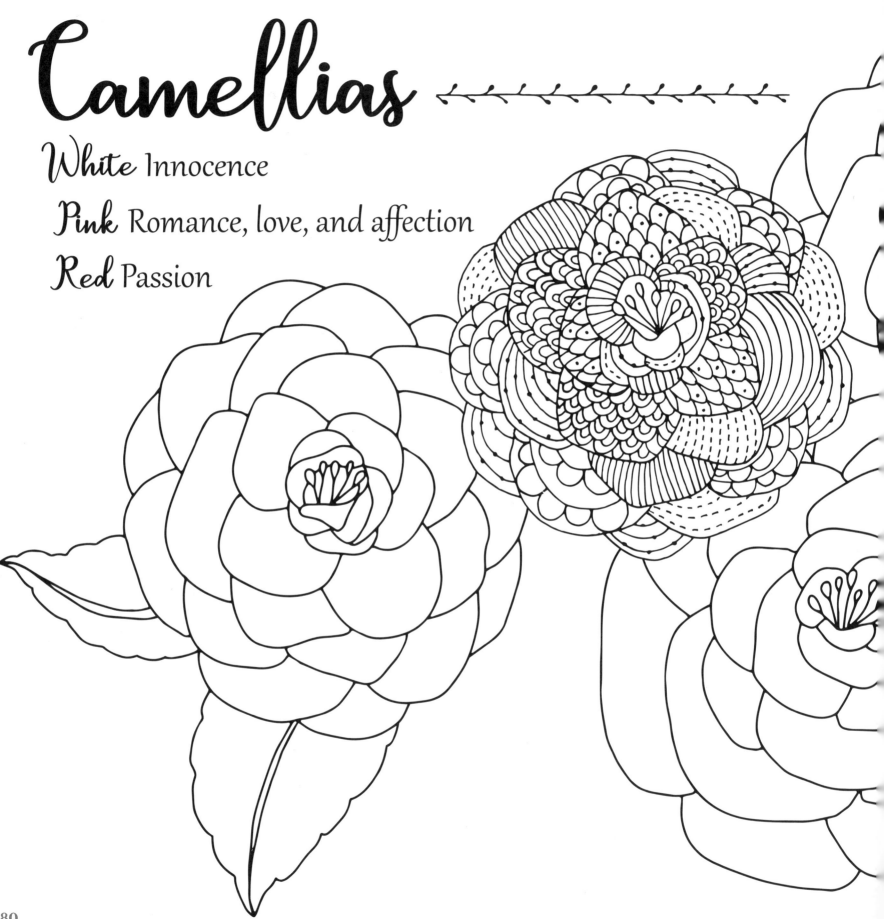

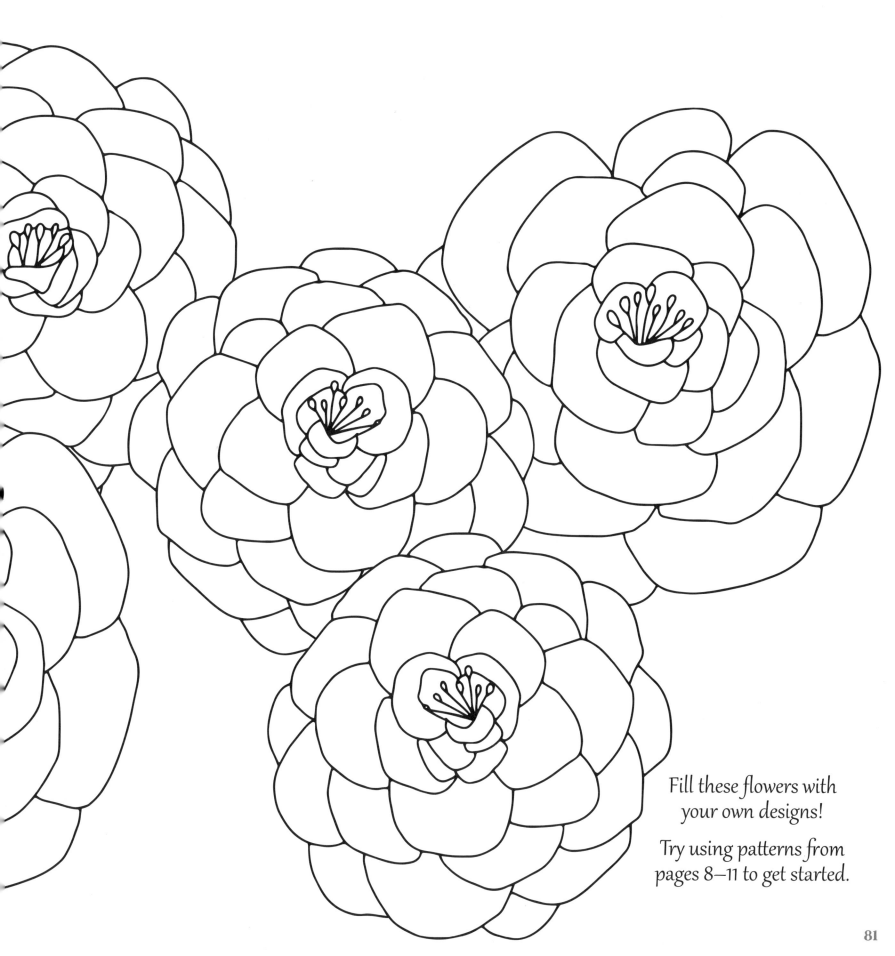

Fill these flowers with
your own designs!

Try using patterns from
pages 8–11 to get started.

DELPHINIUM

(larkspur)
..
Lightness and joy

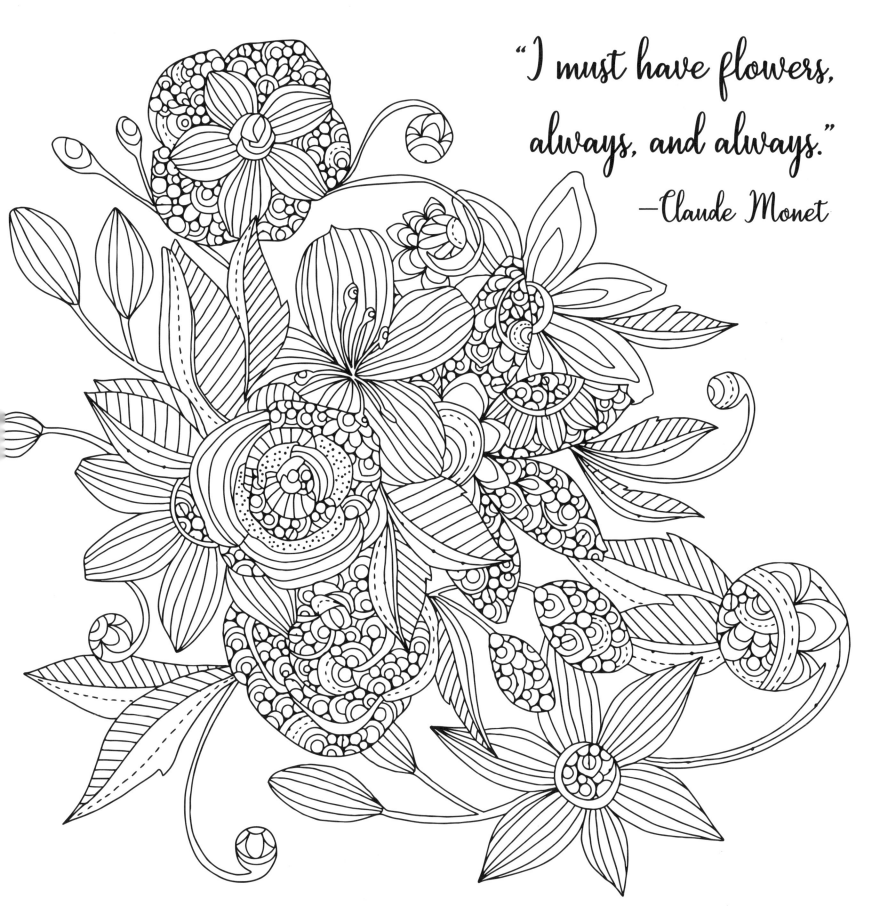

"I must have flowers, always, and always."
—Claude Monet

83

"Where flowers bloom, so does hope." –Lady Bird Johnson

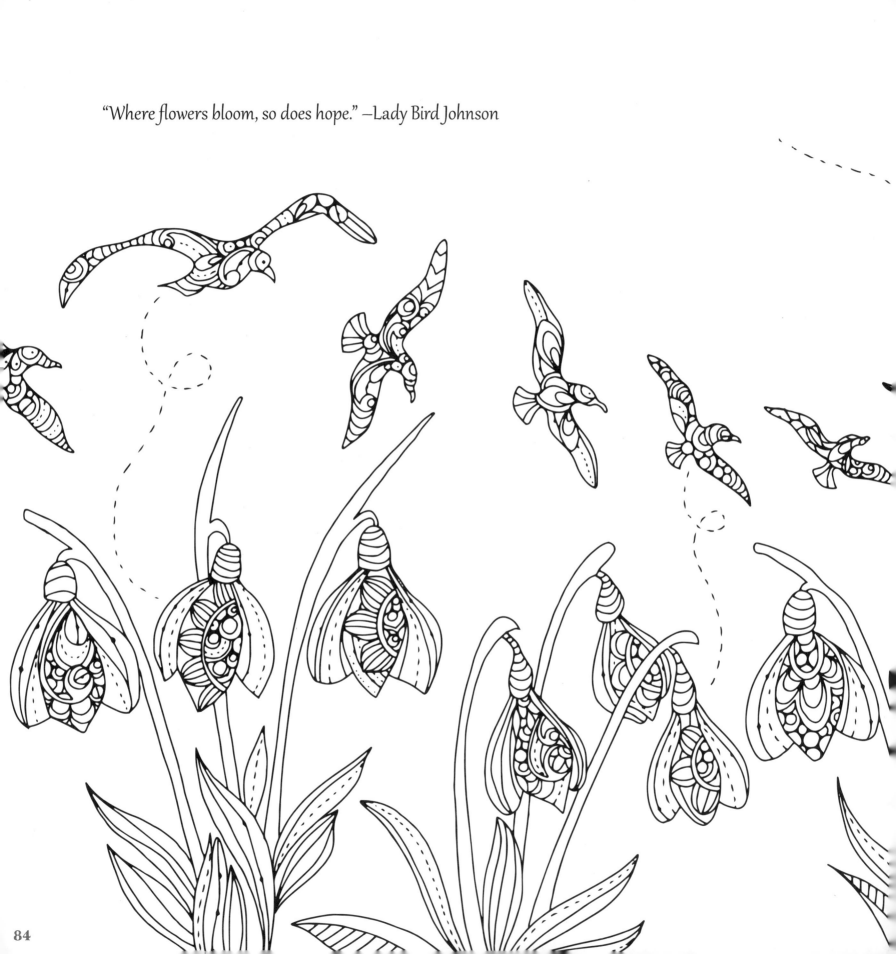

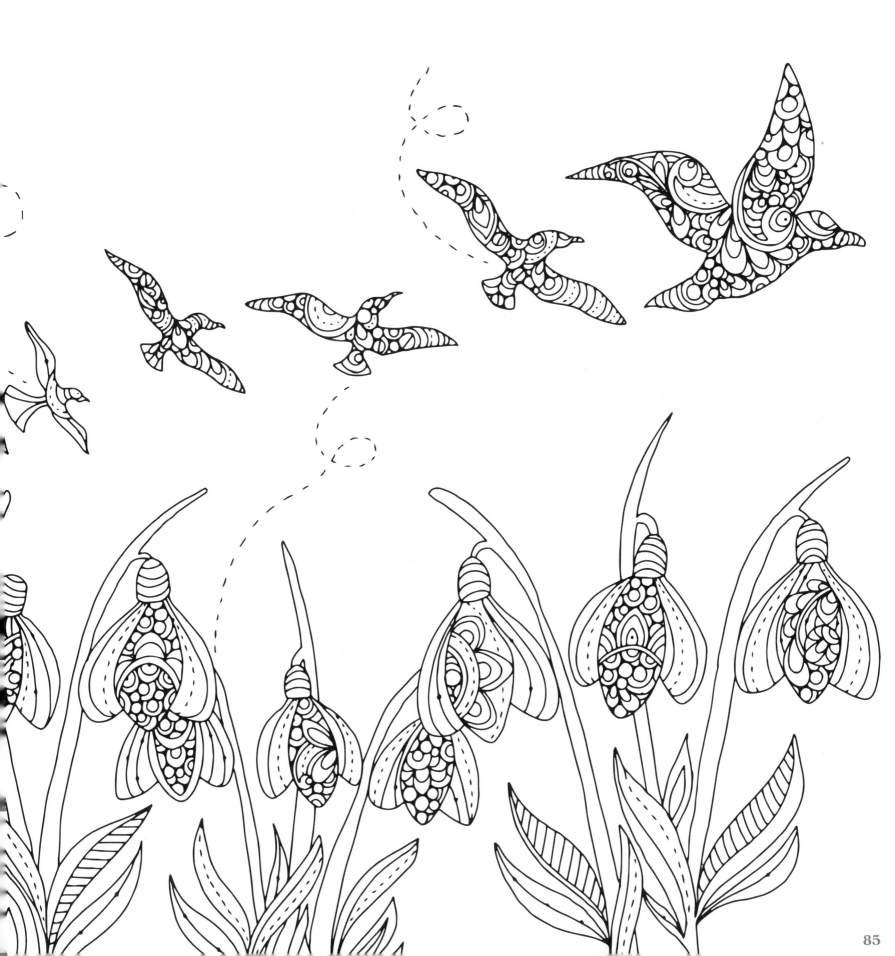

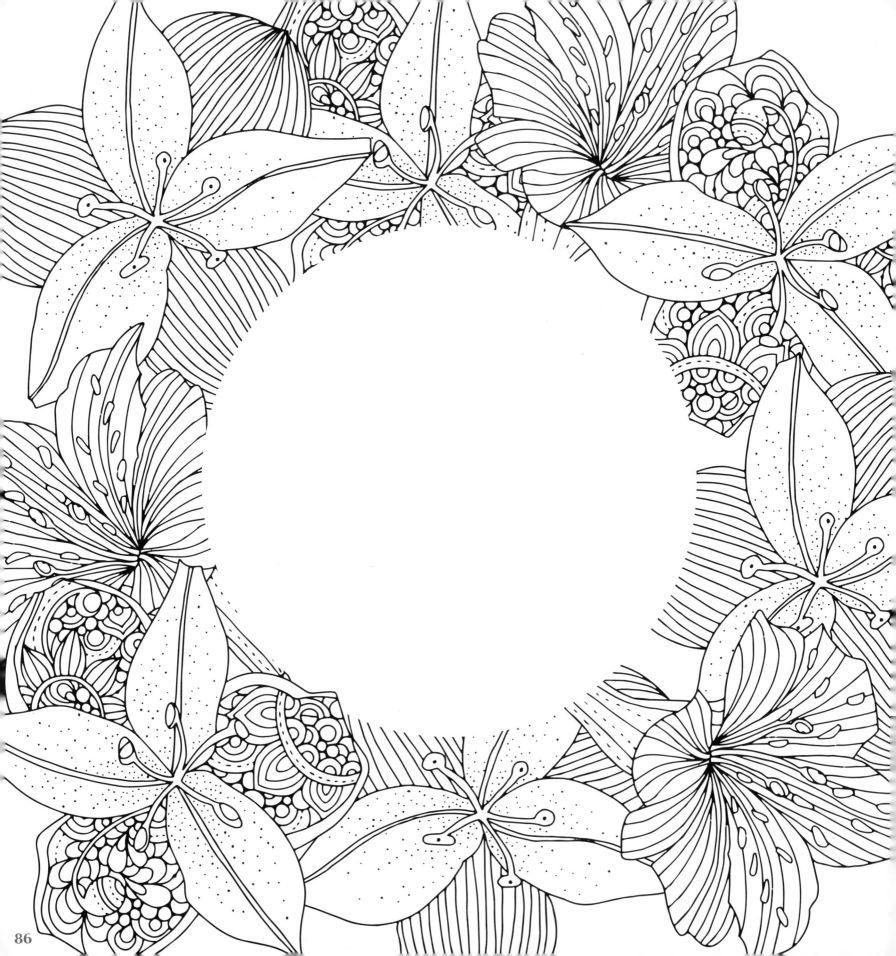

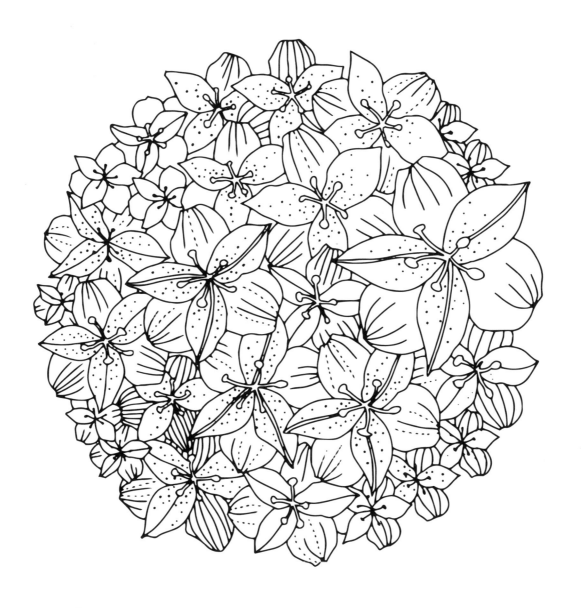

"Earth laughs in flowers."
　　　　　—Ralph Waldo Emerson

What is in your dream garden?

Pick flowers from the samples on pages 12–15, and practice drawing them here, step by step.

Example: Daisy

1

2

3

4

Flower: _____

1

2

3

4

Flower: _____

1　　　　　**2**　　　　　**3**　　　　　**4**

Flower: _____

1　　　　　**2**　　　　　**3**　　　　　**4**

BUSH LILY

Enjoyment

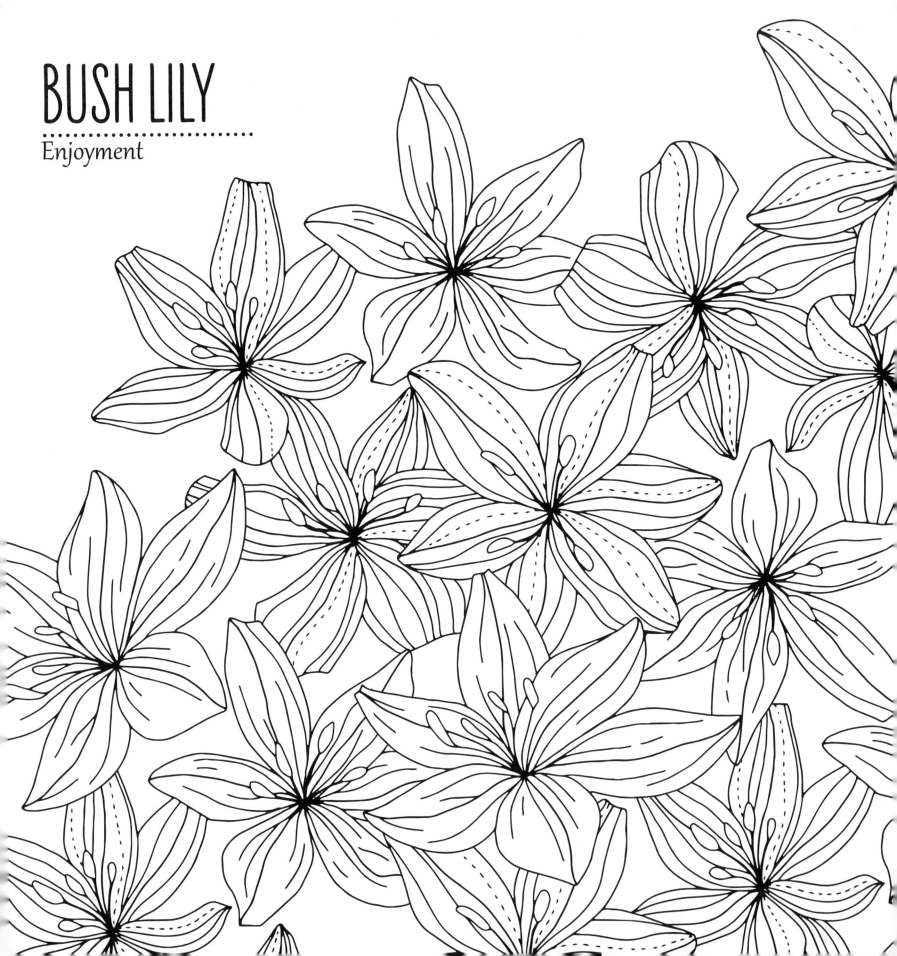

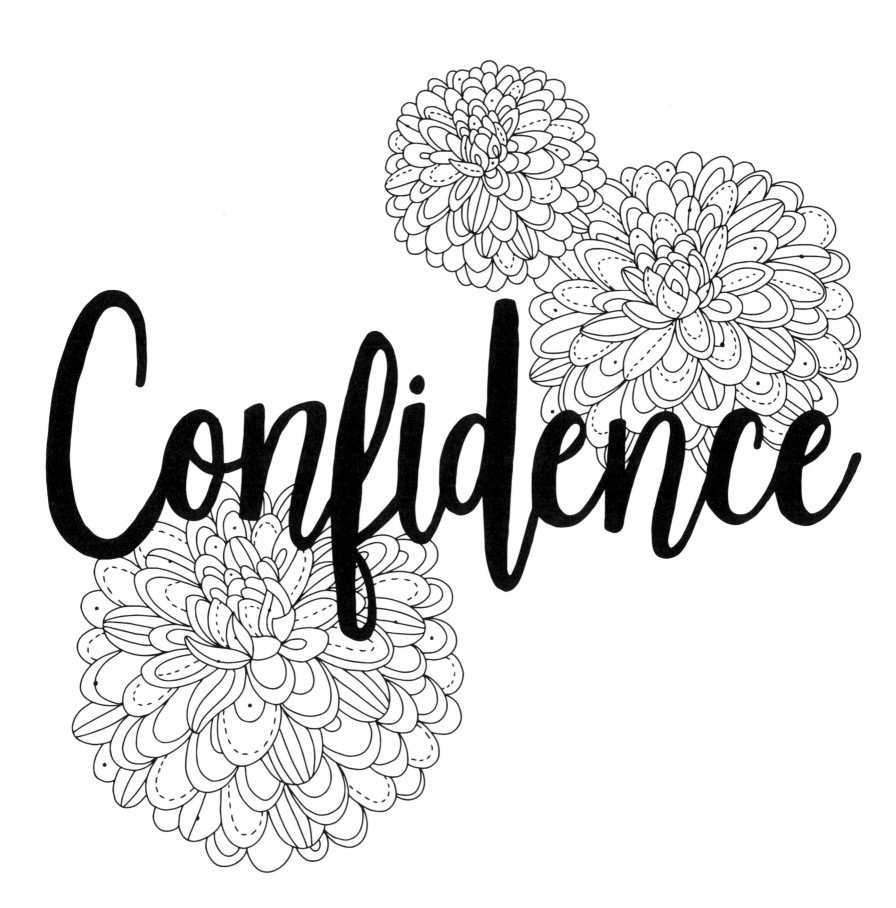

Flowers That Attract Bees

Lilacs • Lavender • Wisteria • Mint • Sunflowers • Poppies • Black-Eyed Susan
Lantana • Snapdragons • Sedums • Pale Purple Coneflowers

What is your favorite flower and why?

Draw and color your favorite flowers from pages 12–15.

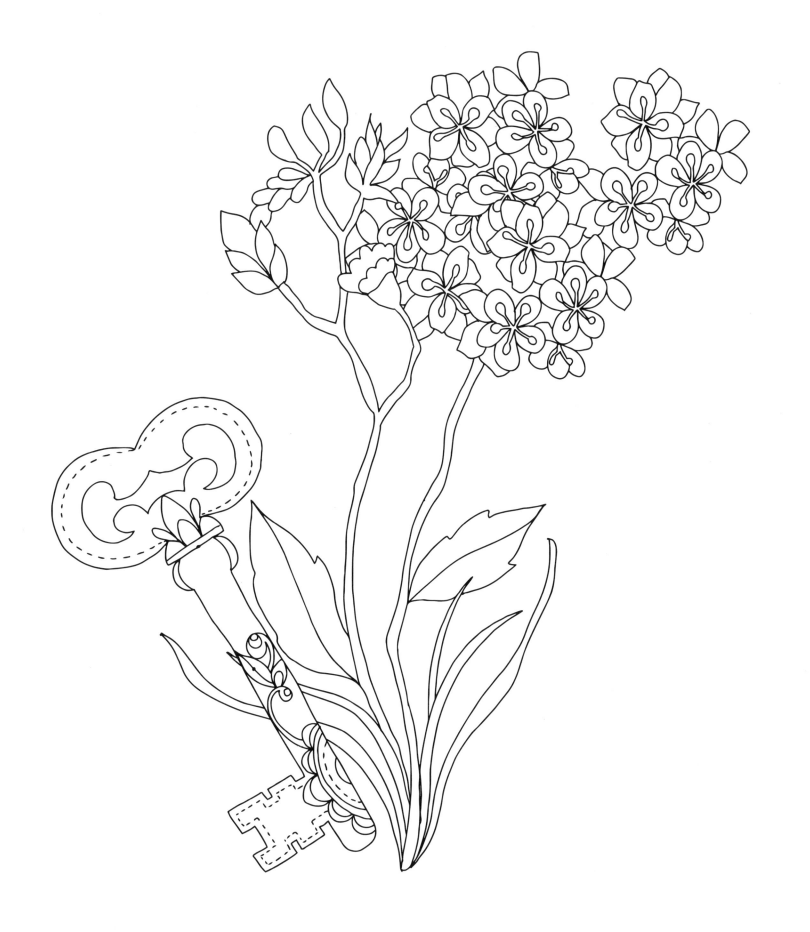

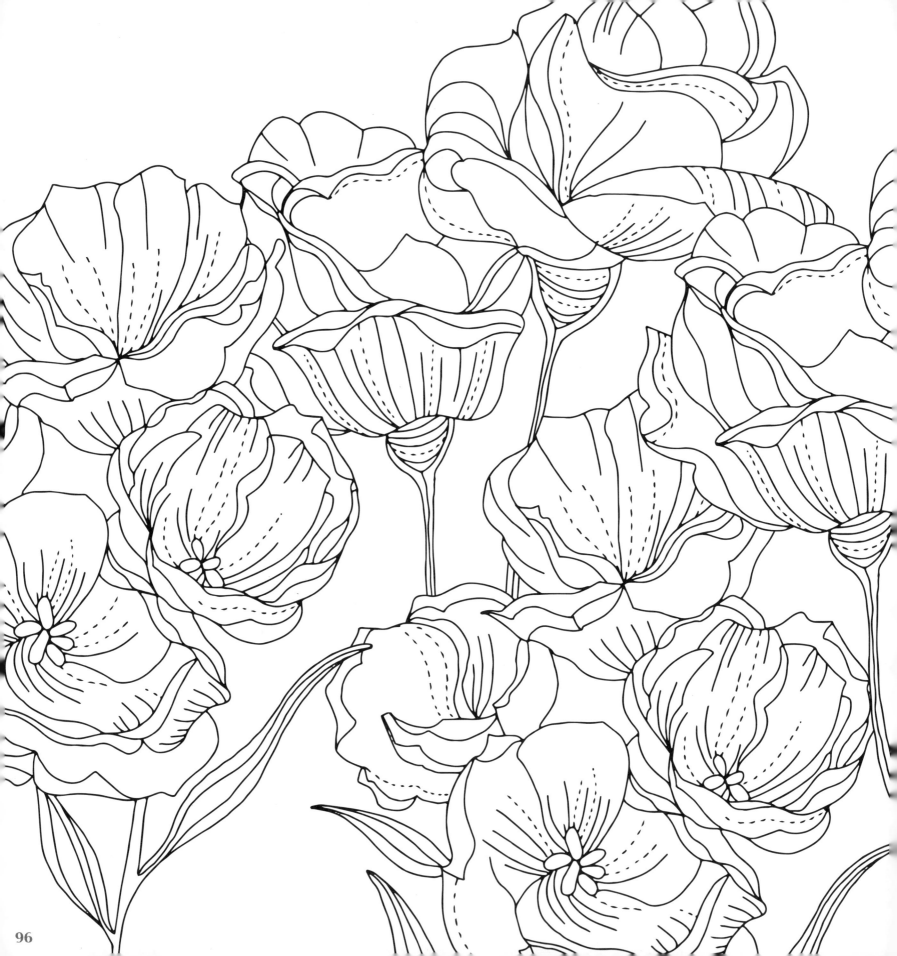

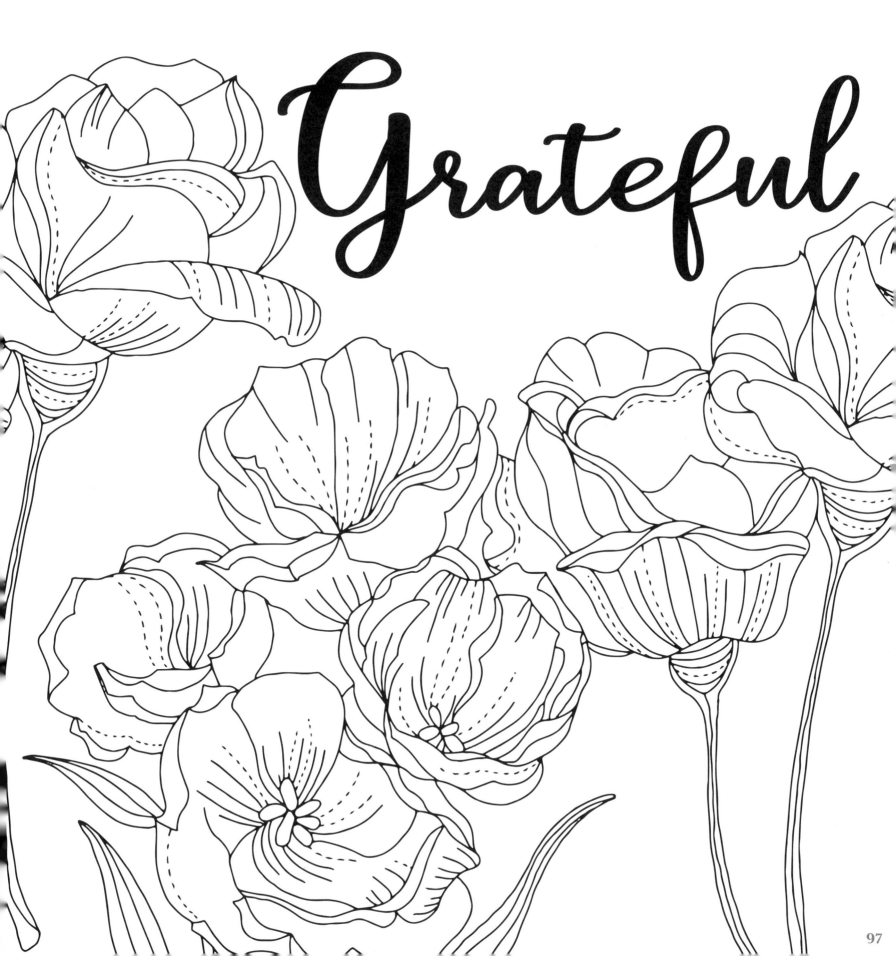

Grateful

WALLFLOWER
Fidelity

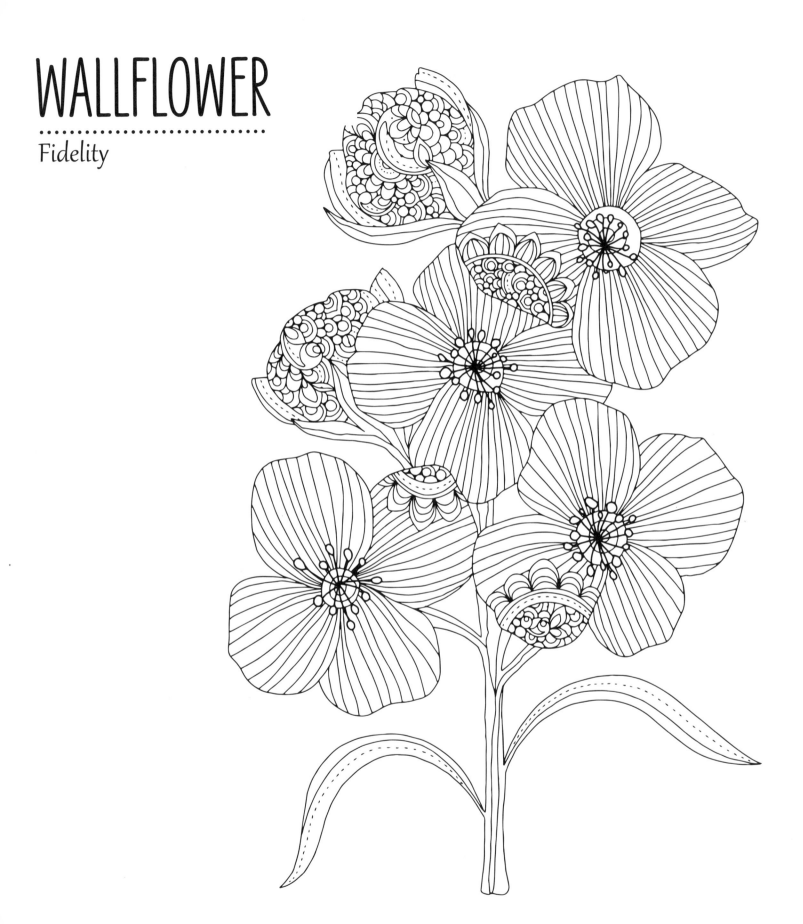

draw a daisy chain

Draw it in steps!

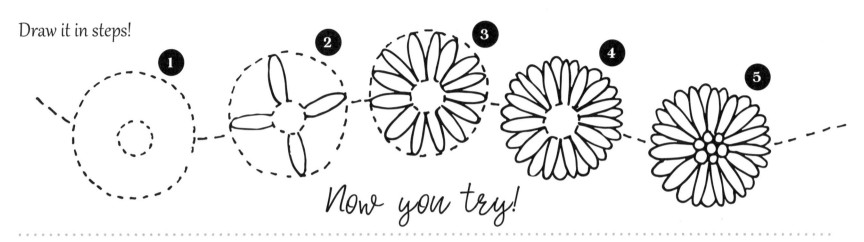

Now you try!

Flower chain #1

Flower chain #2

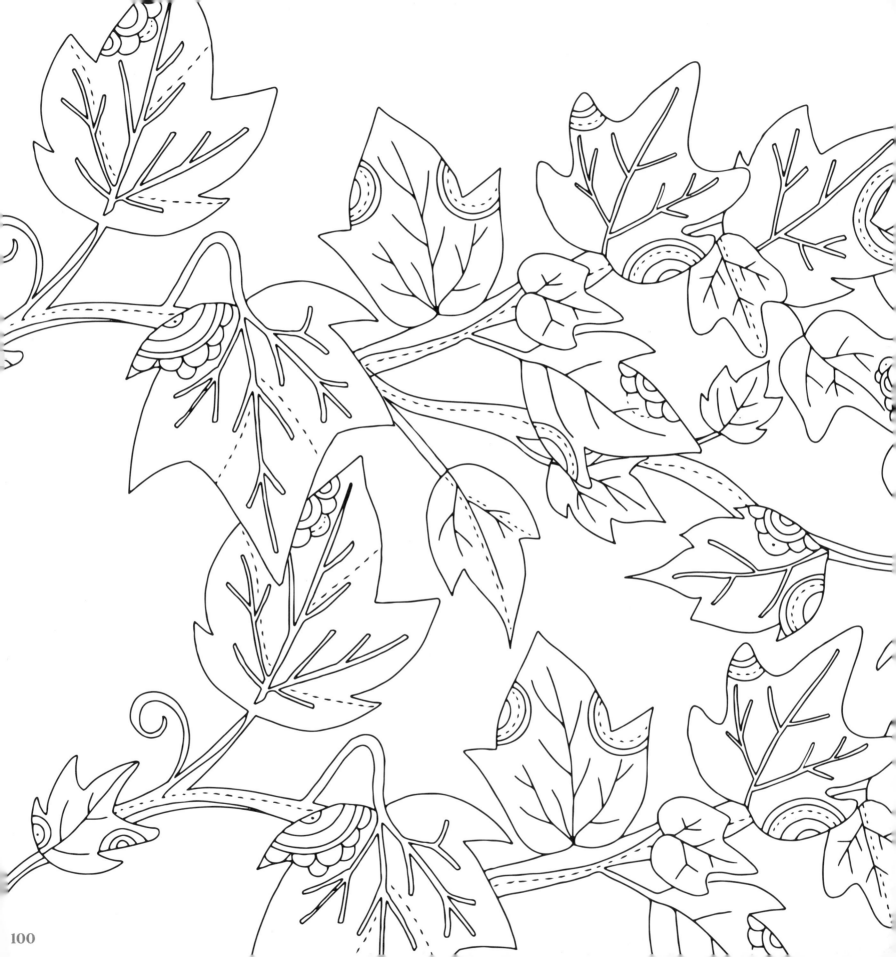

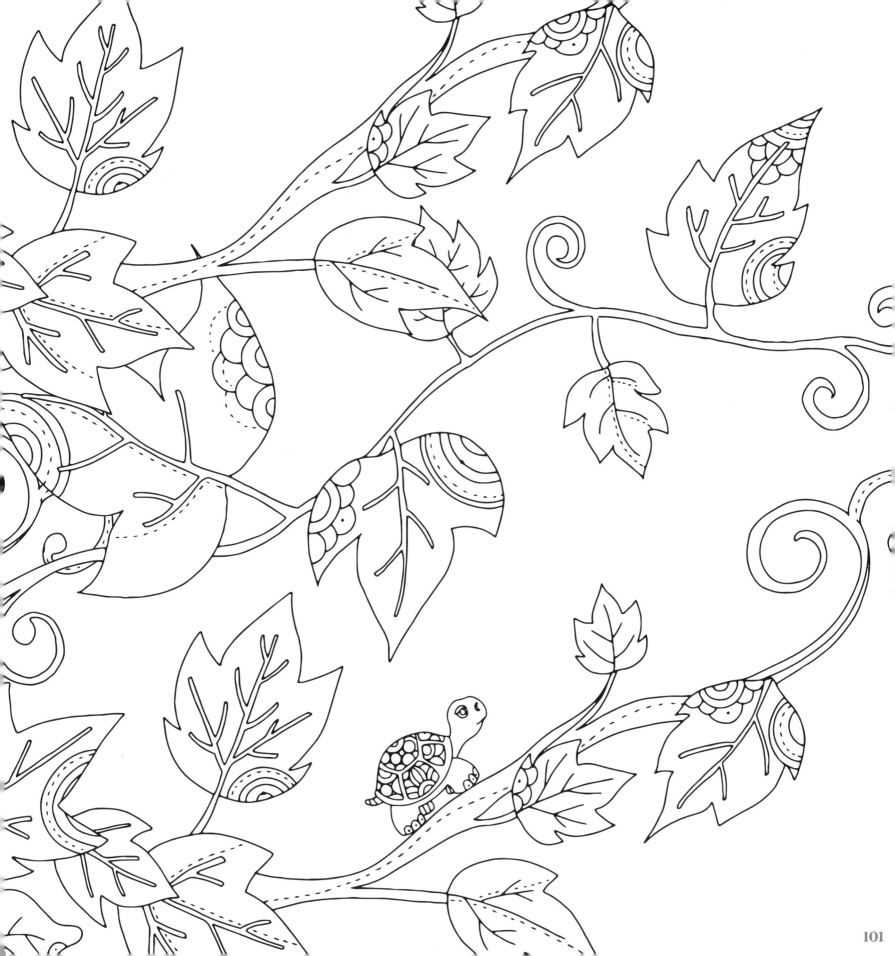

Fill with your own designs!

Try using patterns from pages 8–11 to get started.

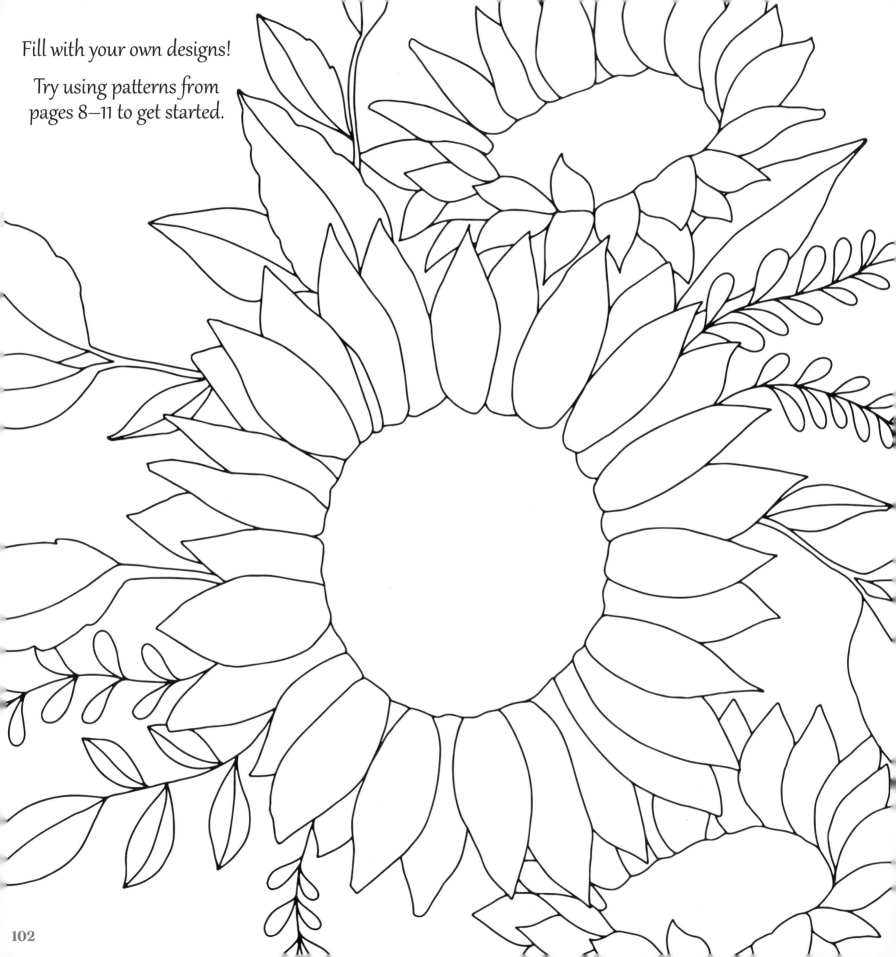

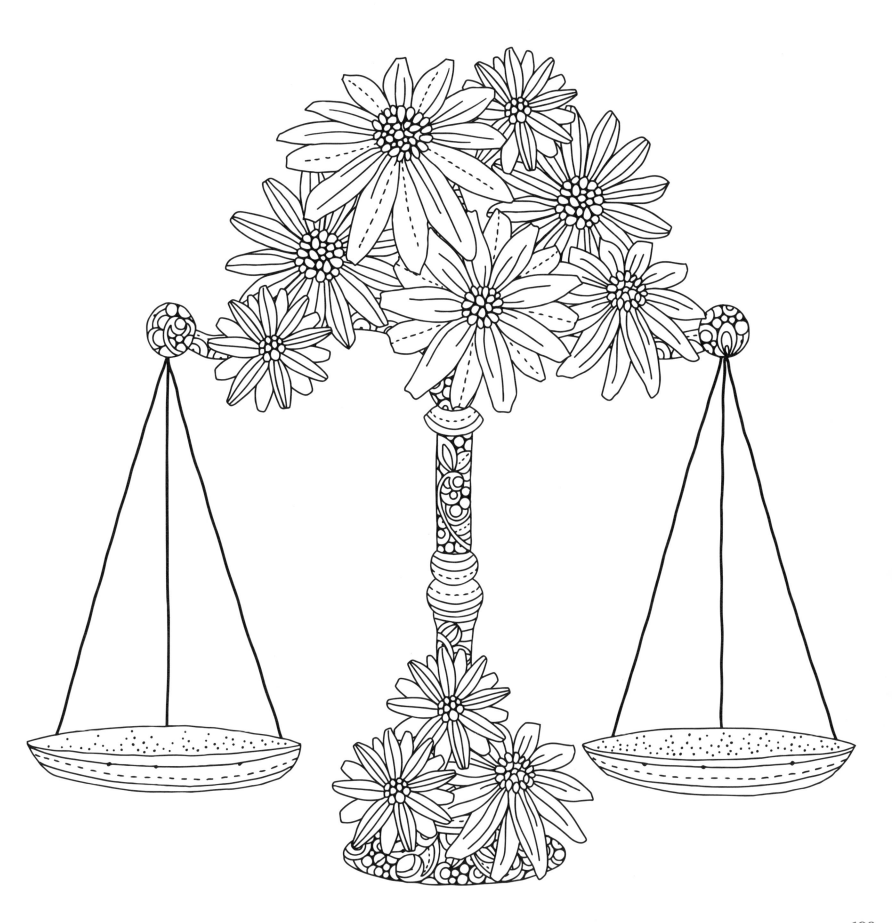

FORGET-ME-NOT

Remembrance

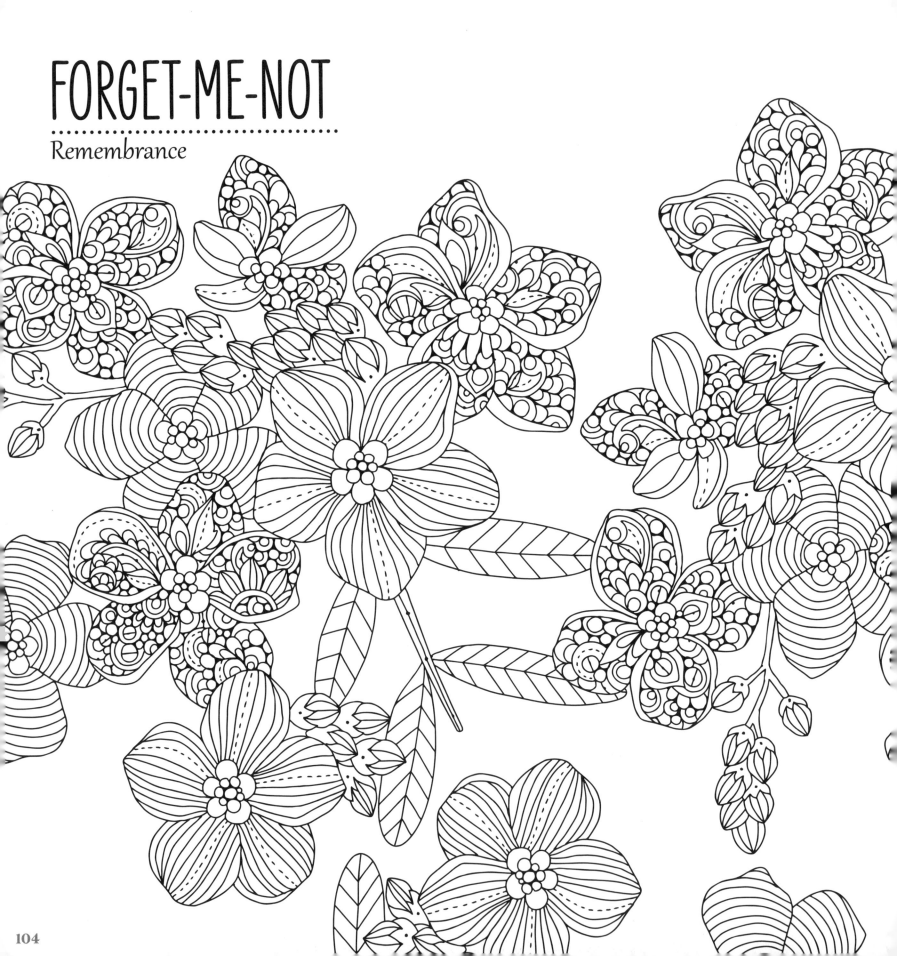

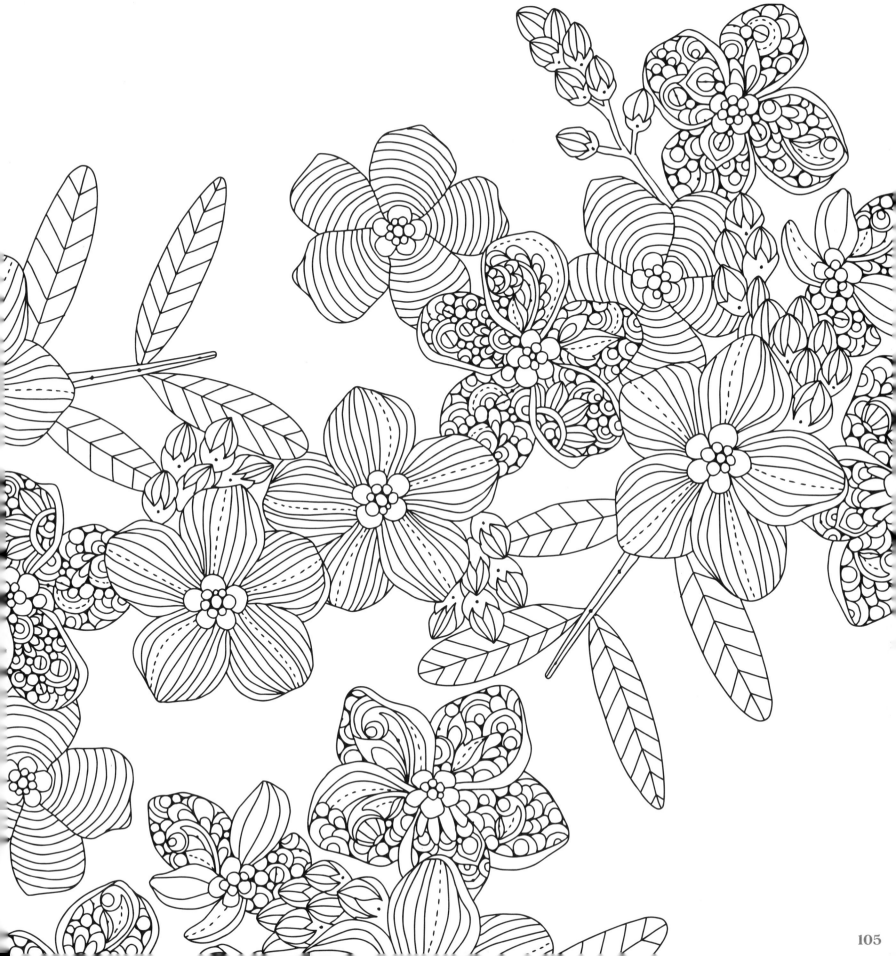

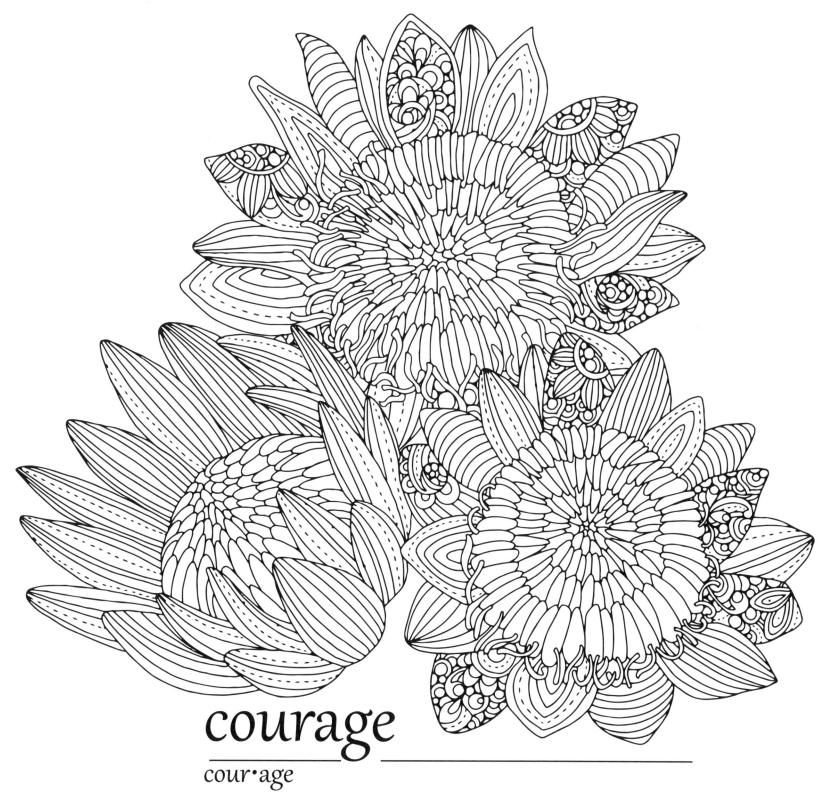

courage

cour·age

- the ability to do something that frightens you
- strength in the face of pain or grief

Roses

- **RED**
 Love and romance

- **YELLOW**
 Friendship, joy, and get well

- **LAVENDER**
 Enchantment and majesty

- **DARK PINK**
 Gratitude and appreciation

- **LIGHT PINK**
 Gentleness and admiration

- **WHITE**
 Purity, innocence, and spirituality

- **ORANGE**
 Desire, enthusiasm, and passion

- **SALMON**
 Desire and excitement

- **CREAM**
 Charm and thoughtfulness

Fill with your own designs!

Try using patterns from pages 8–11 to get started.

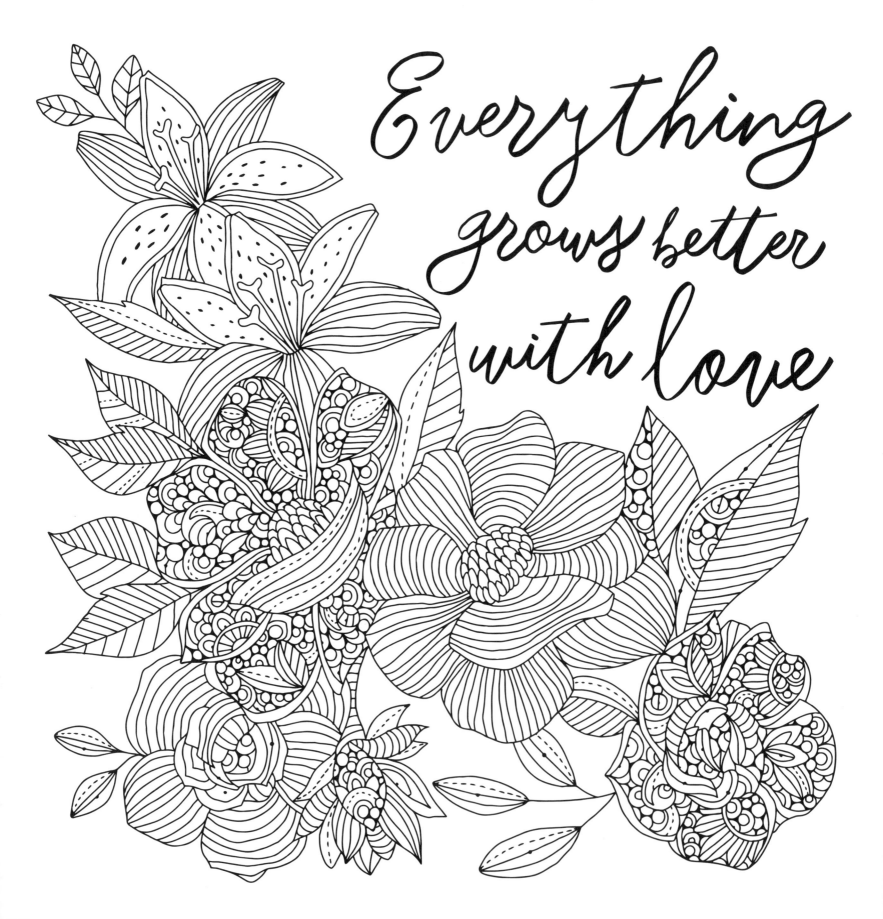

Everything grows better with love

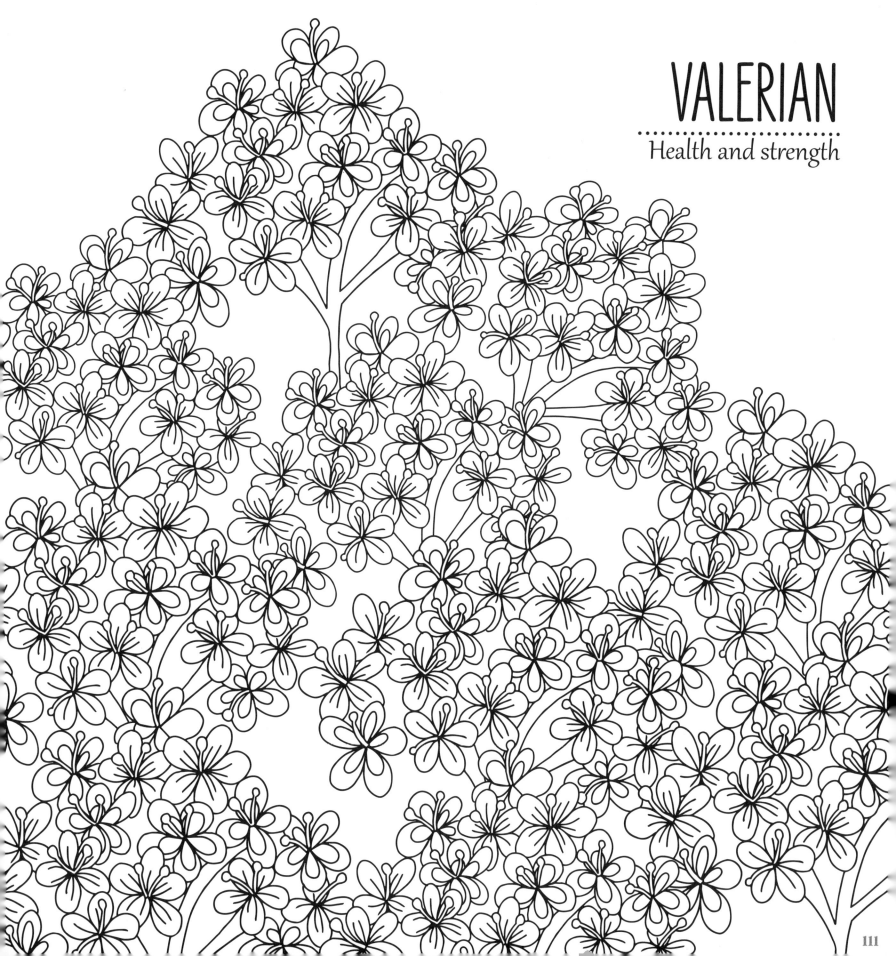

VALERIAN

Health and strength

Unusual flowers

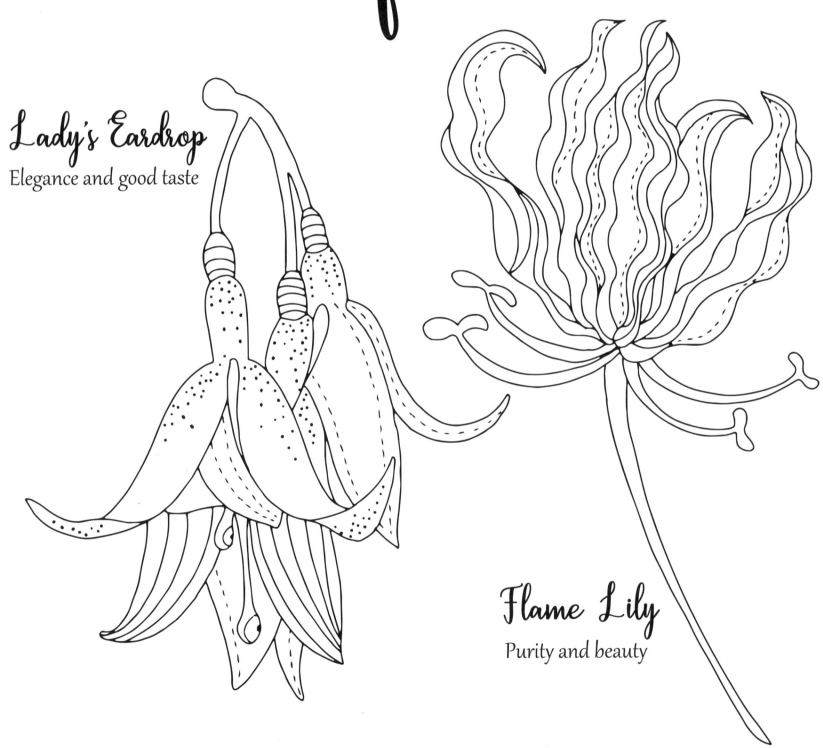

Lady's Eardrop

Elegance and good taste

Flame Lily

Purity and beauty

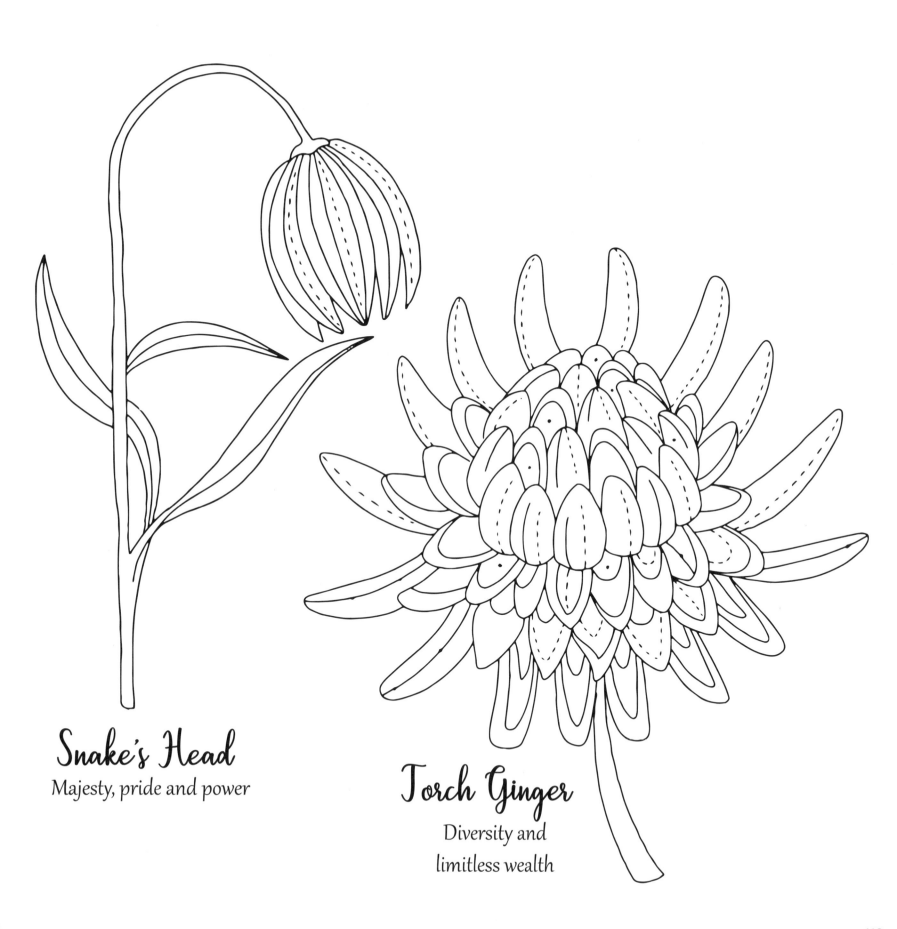

Snake's Head
Majesty, pride and power

Torch Ginger
Diversity and
limitless wealth

113

VISIT A PUBLIC GARDEN

notes:

...

...

...

Draw and color what you see. Use the flower samples on pages 12–15 for guidance.

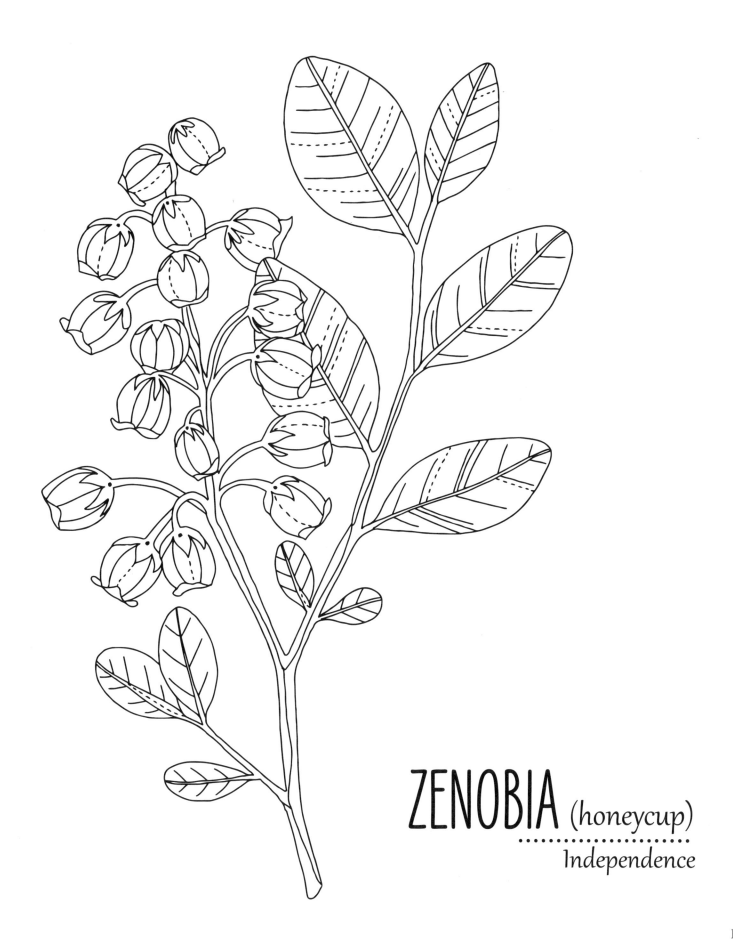

ZENOBIA (honeycup)
.........................
Independence

LEWISIA (bitterroot)
New beginnings

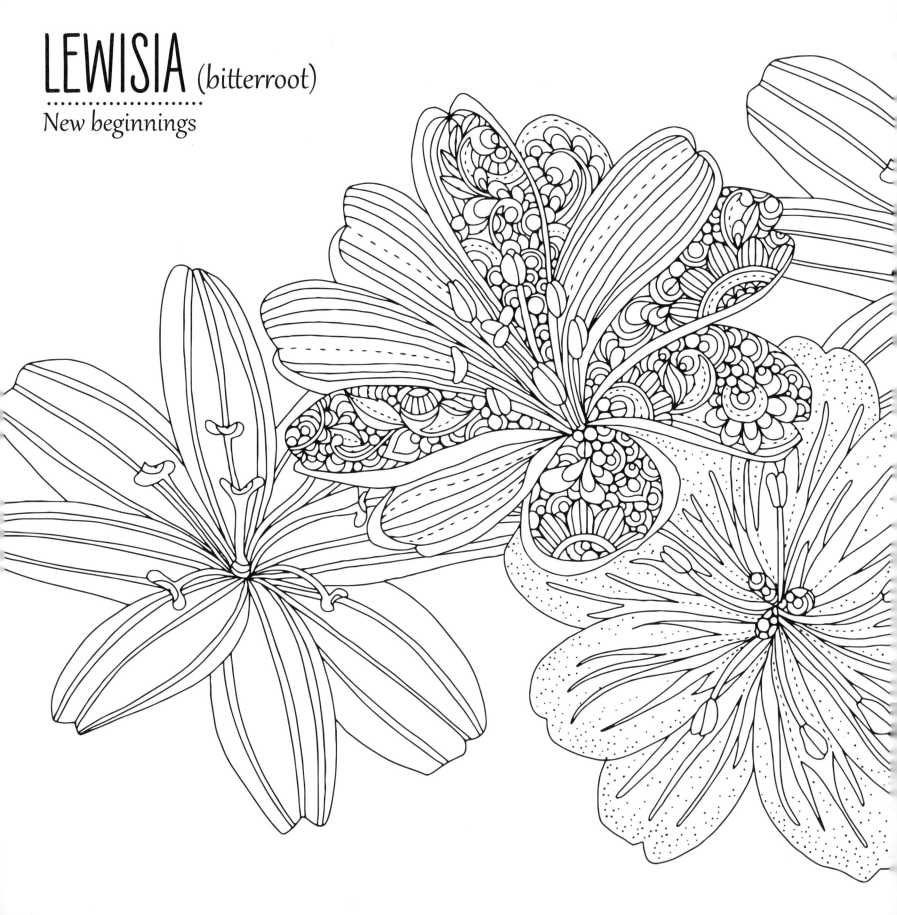

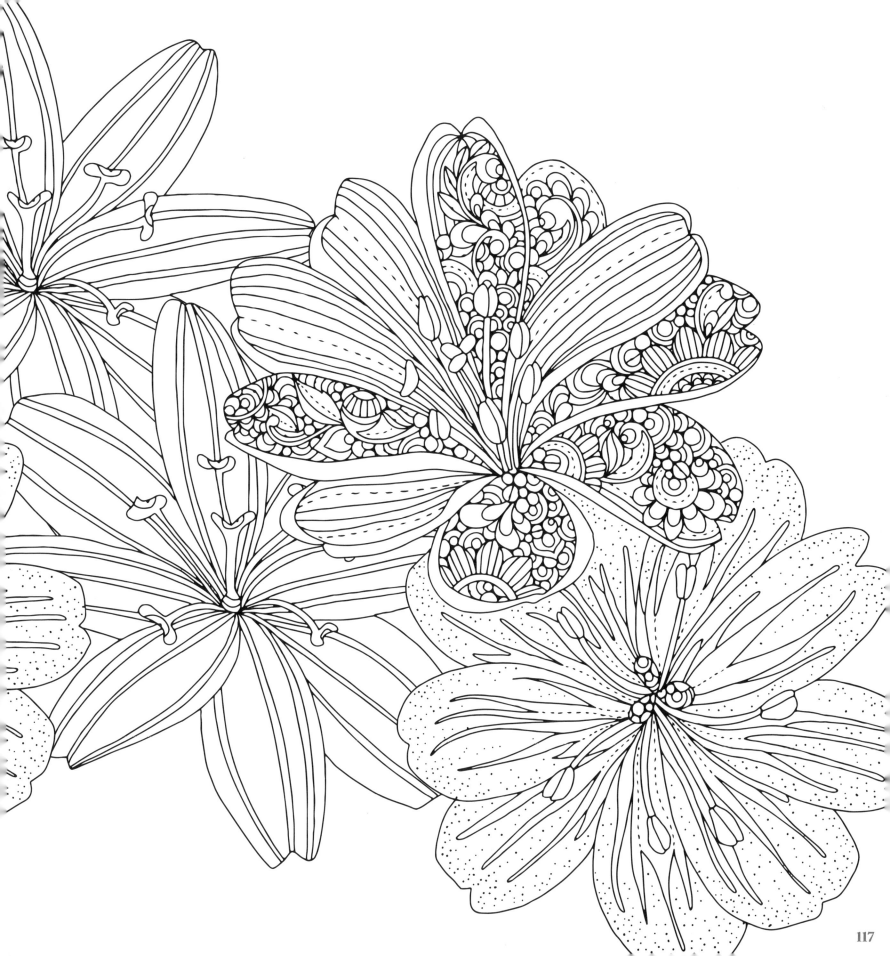

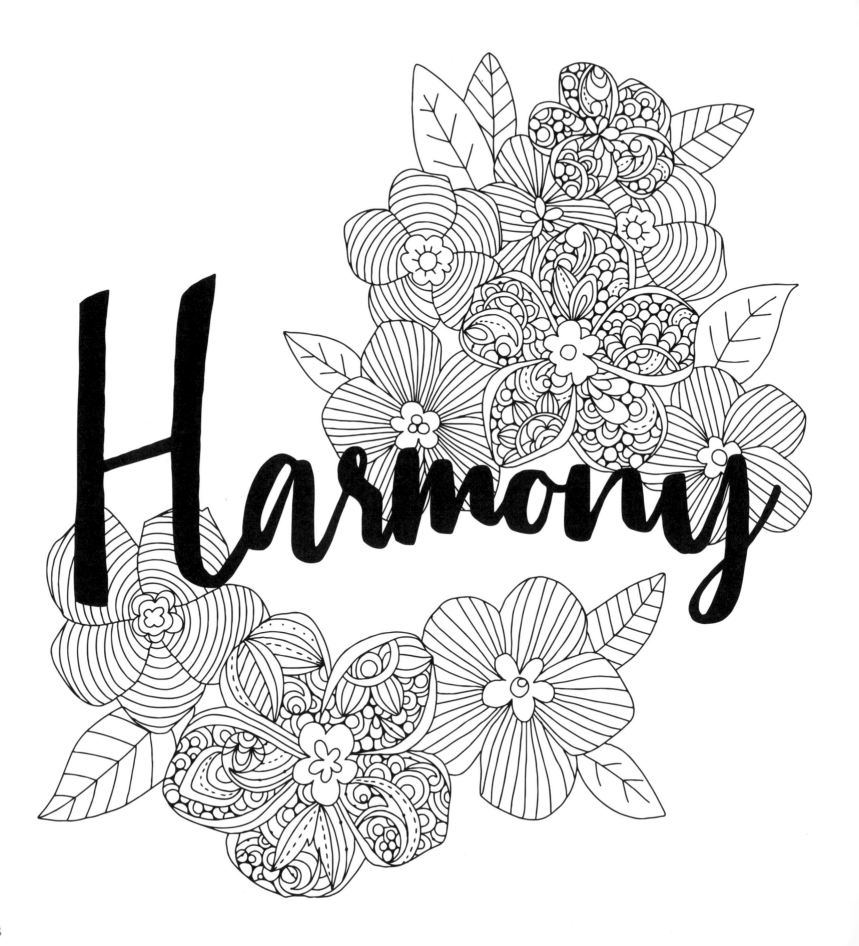

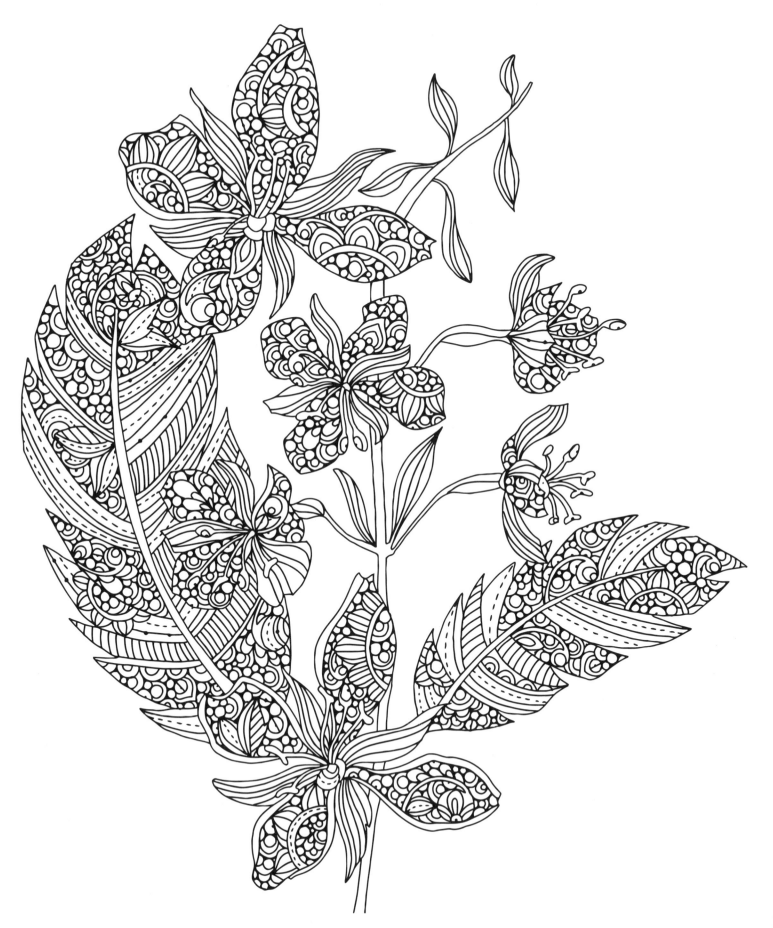

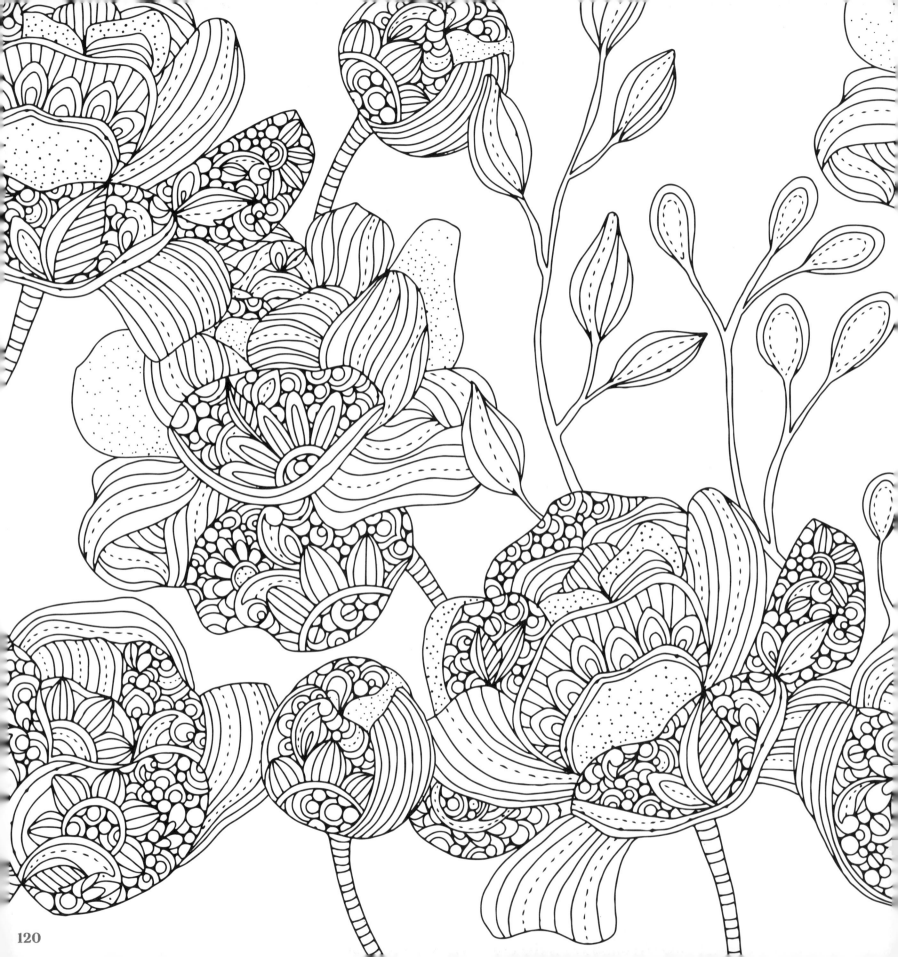

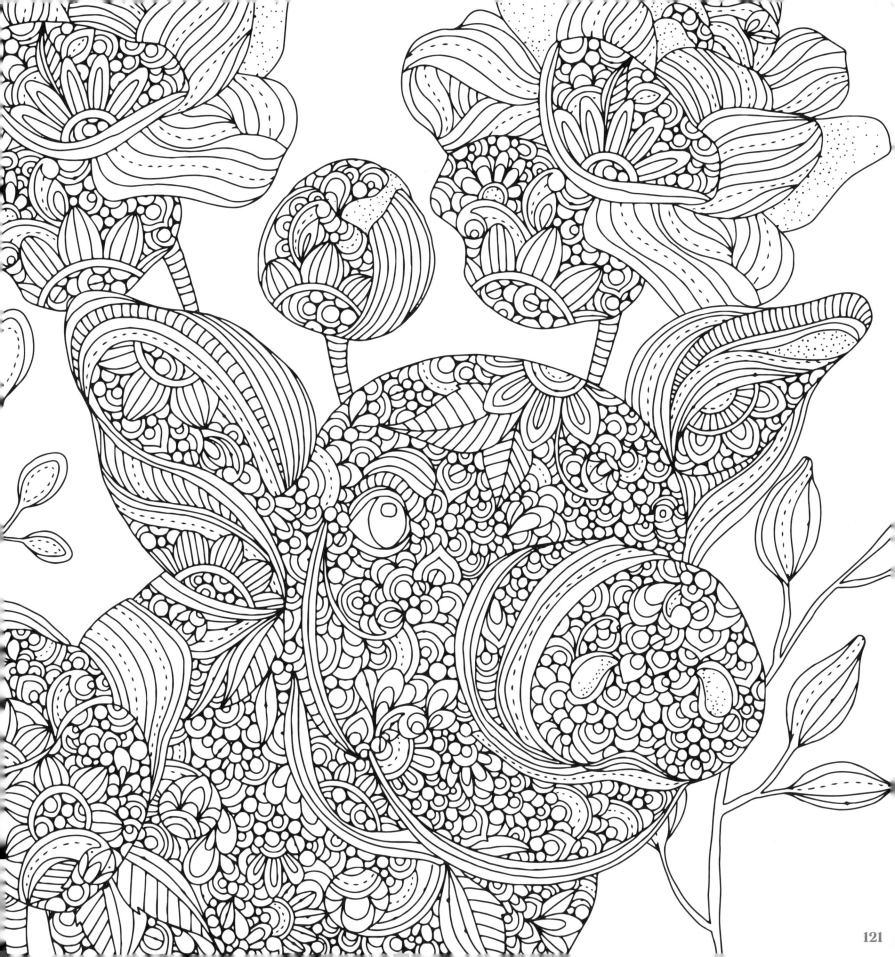

"Daisies, simple and sweet. Daisies are the way to win my heart."
—Patrick Rothfuss

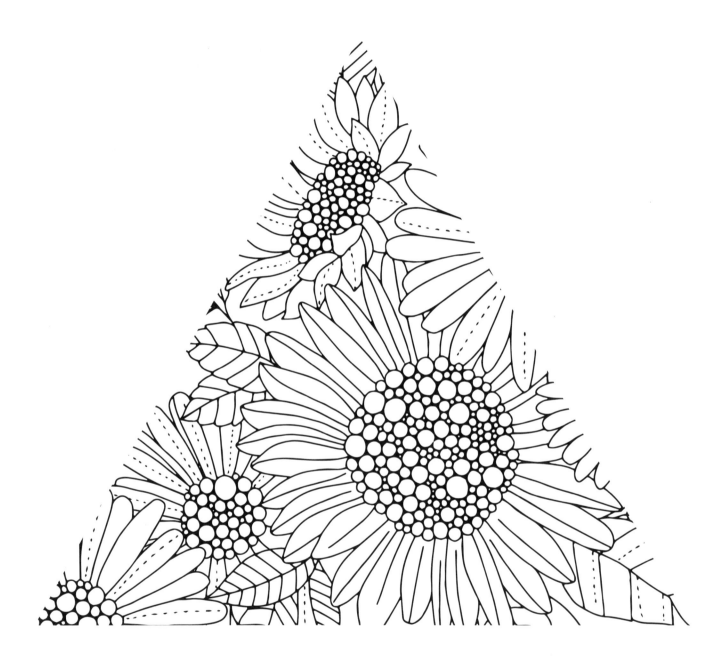

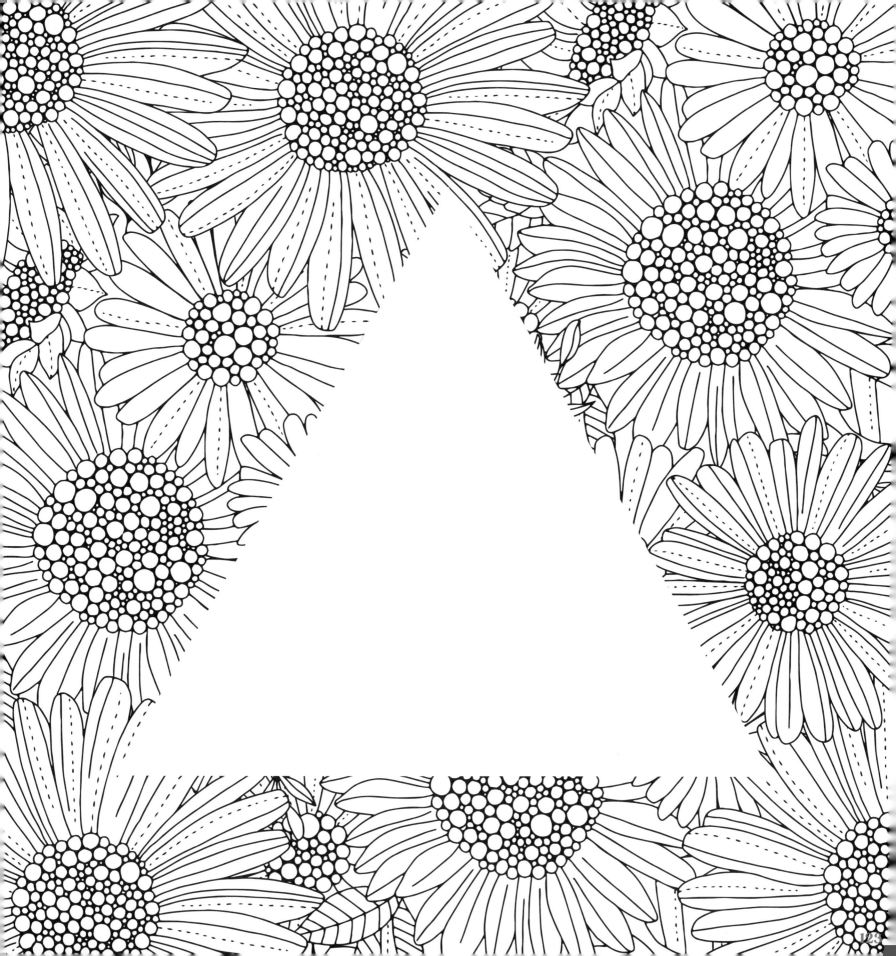

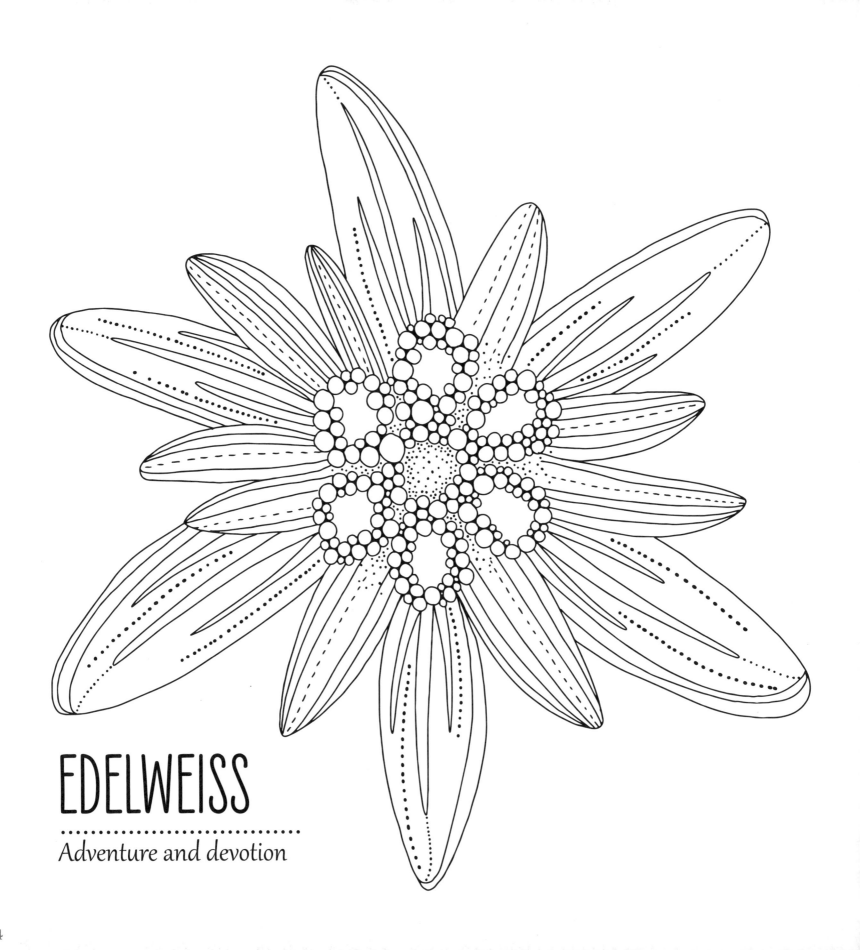

EDELWEISS

Adventure and devotion

BLOOM

where you are planted

Friendship

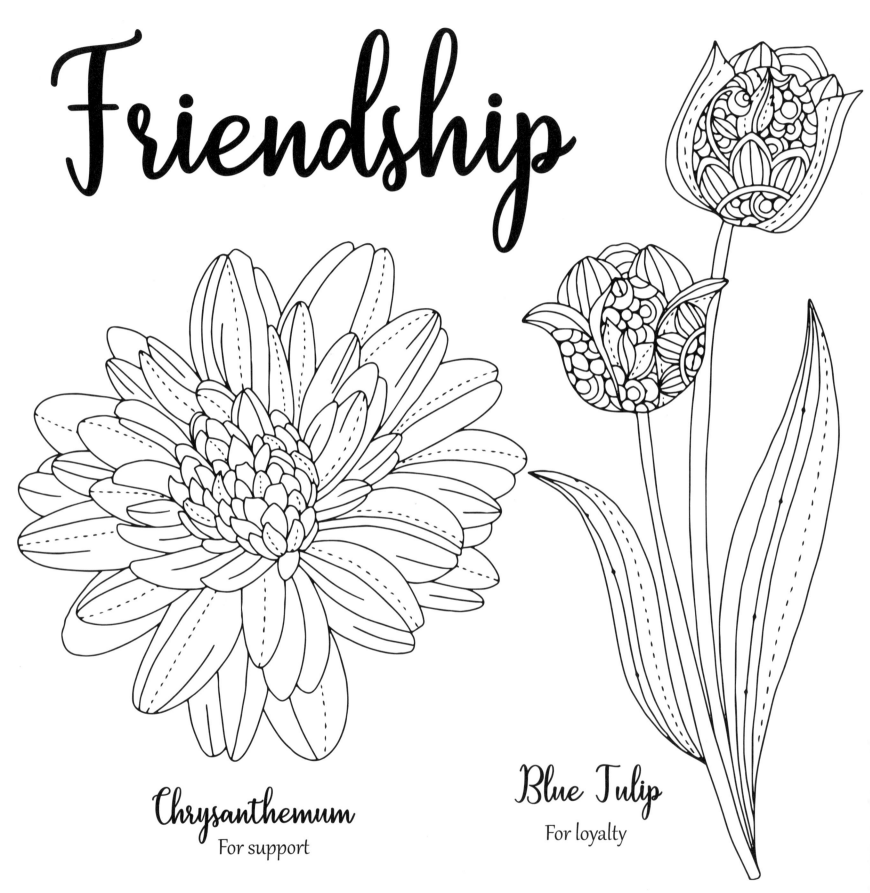

Chrysanthemum
For support

Blue Tulip
For loyalty

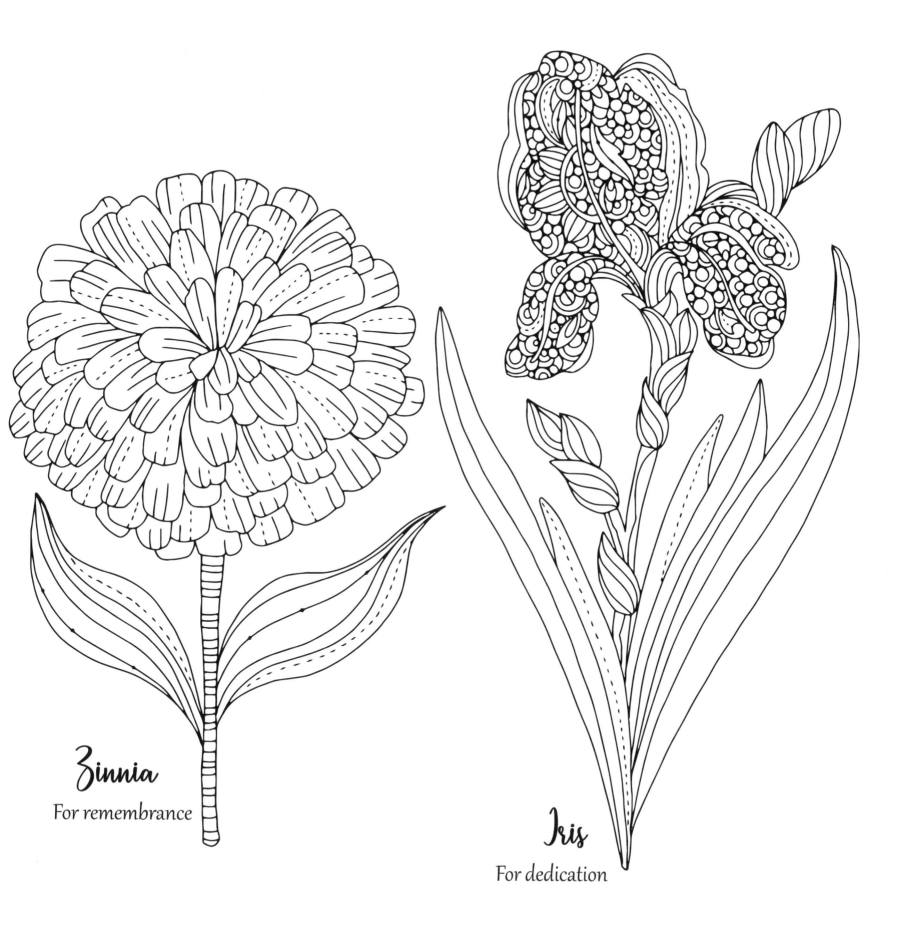

Zinnia

For remembrance

Iris

For dedication

collect quotes about flowers

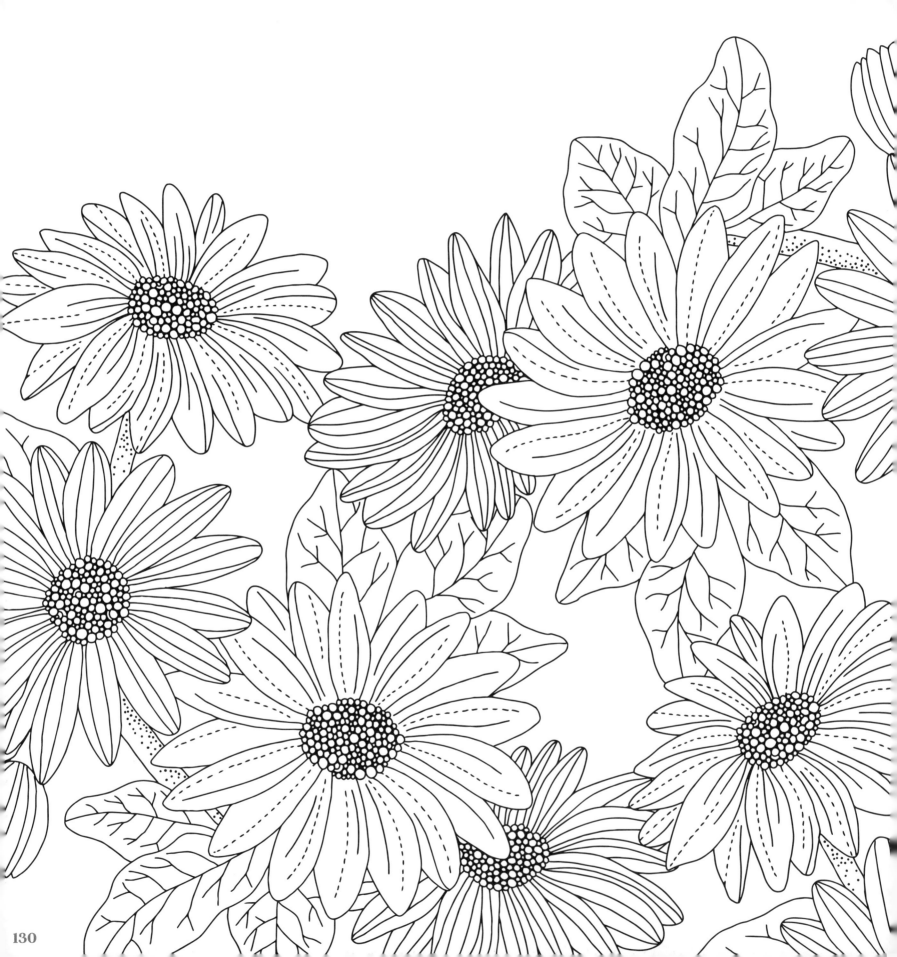

AFRICAN DAISY

Purity and innocence

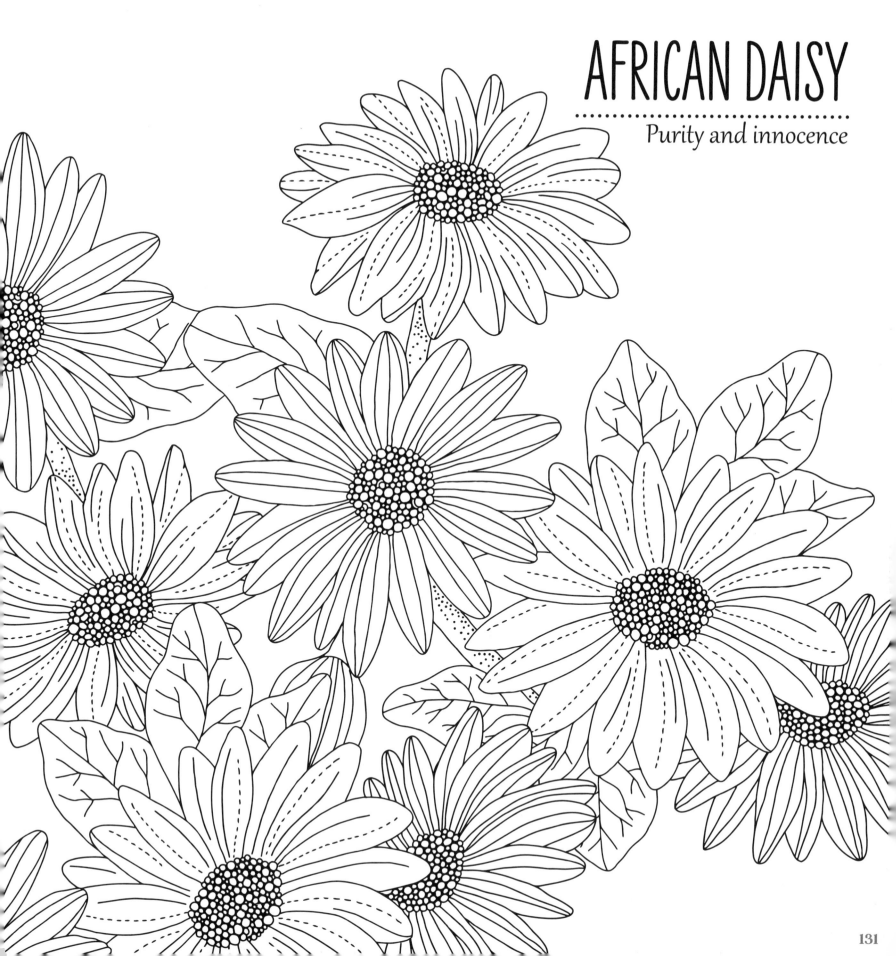

Fill with your own pattern! Use the patterns on pages 8–11 for inspiration.

PASSION FLOWER

Passion

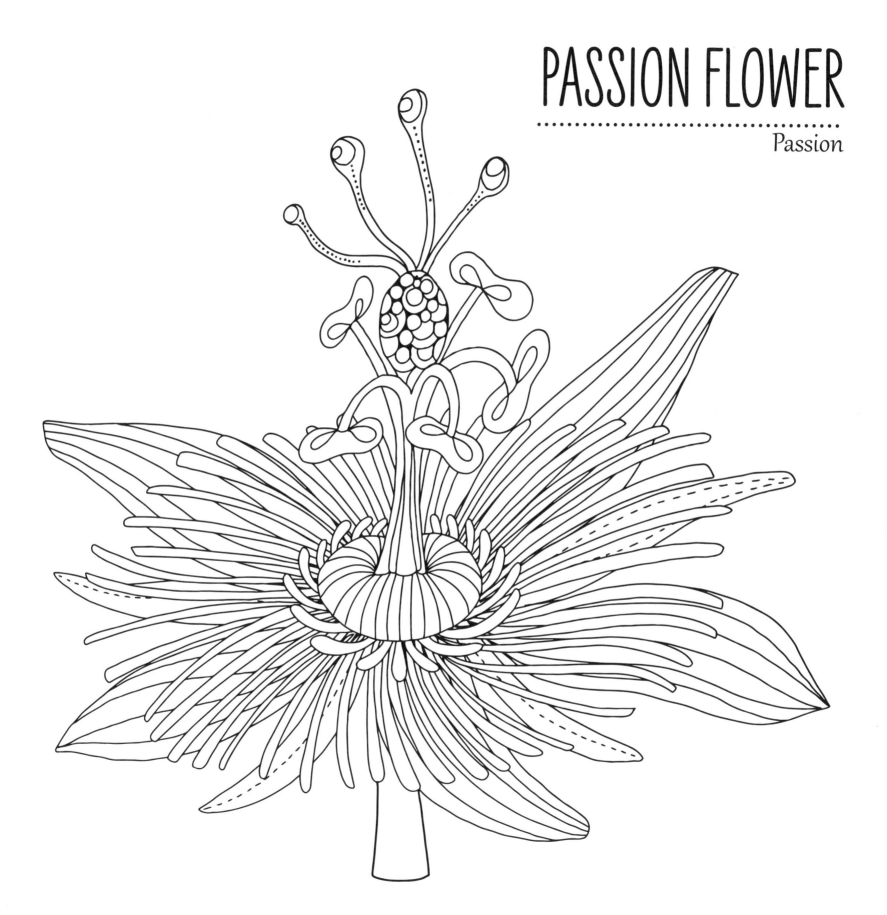

QUESNELIA

Endurance and hardiness

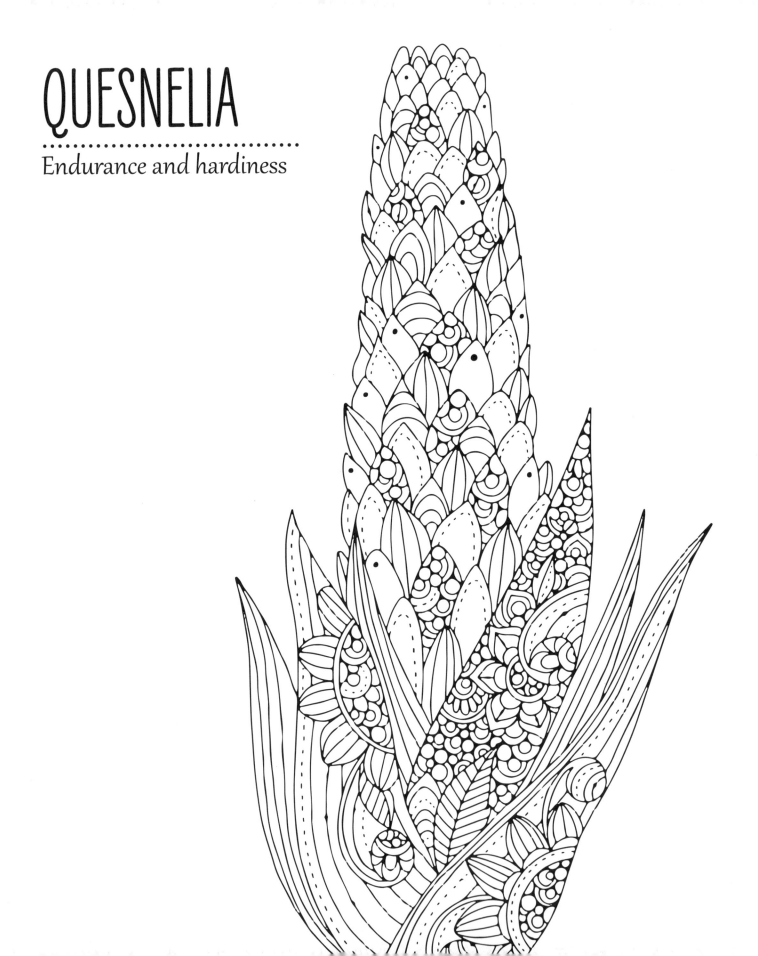

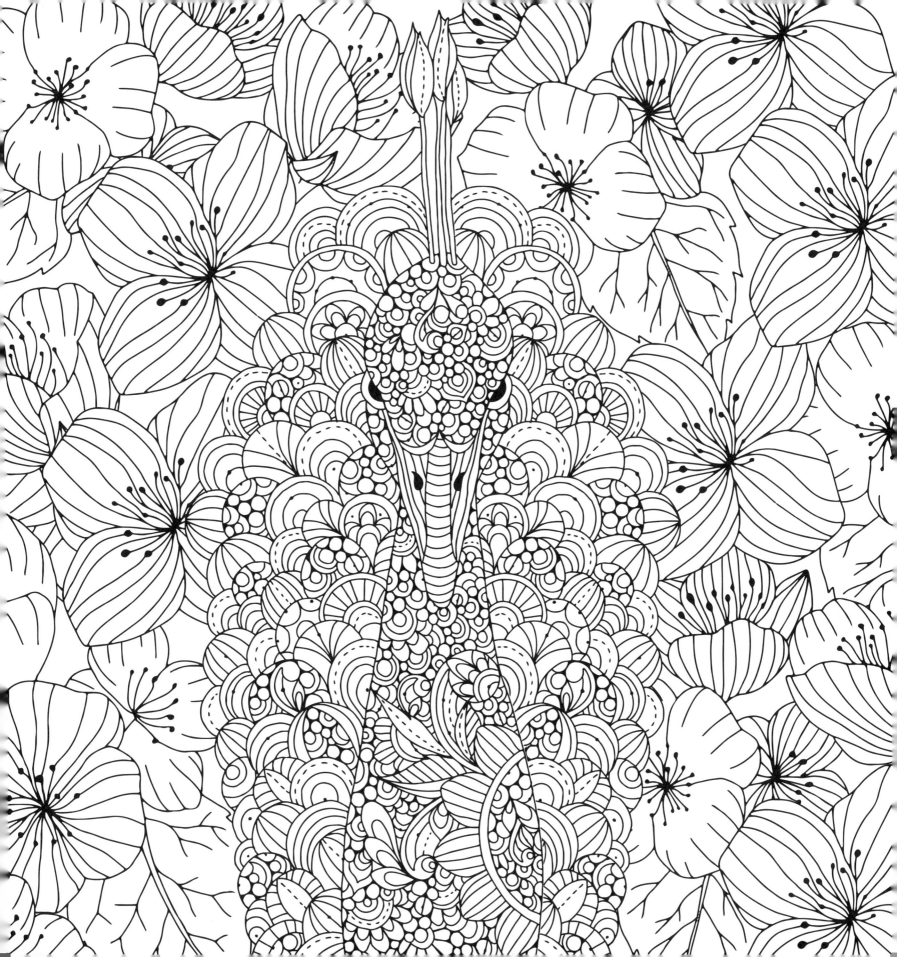

Fill these flowers with your own designs! Try some patterns from pages 8–11 to get started.

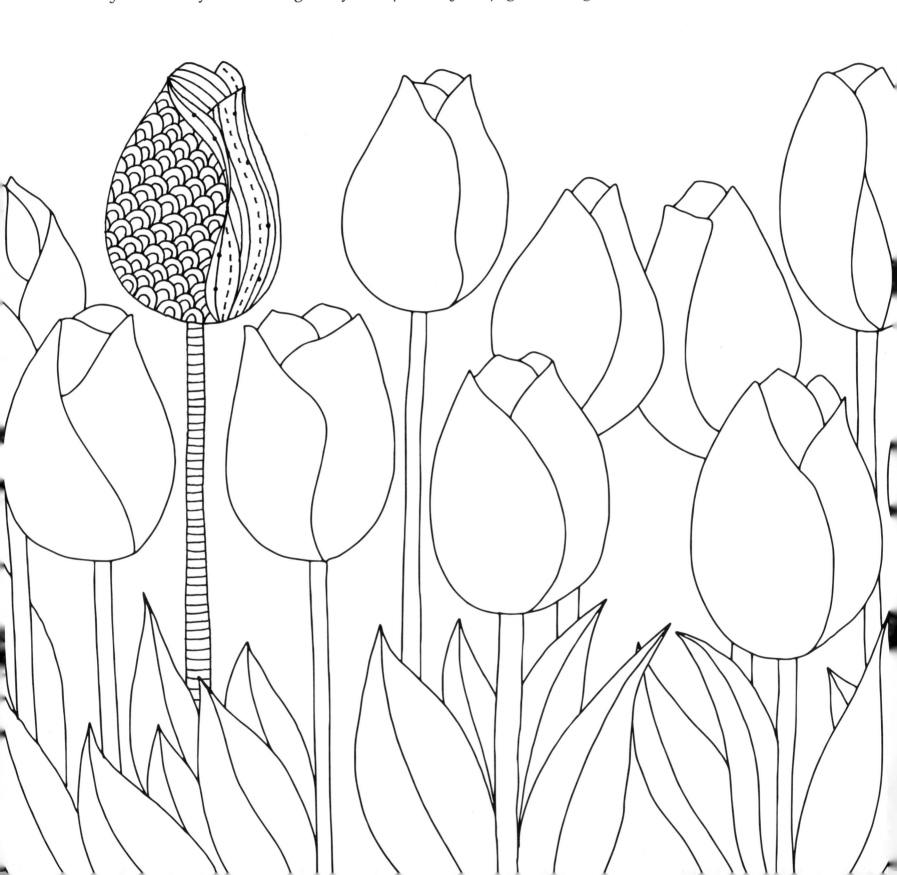

YUCCA

Purification

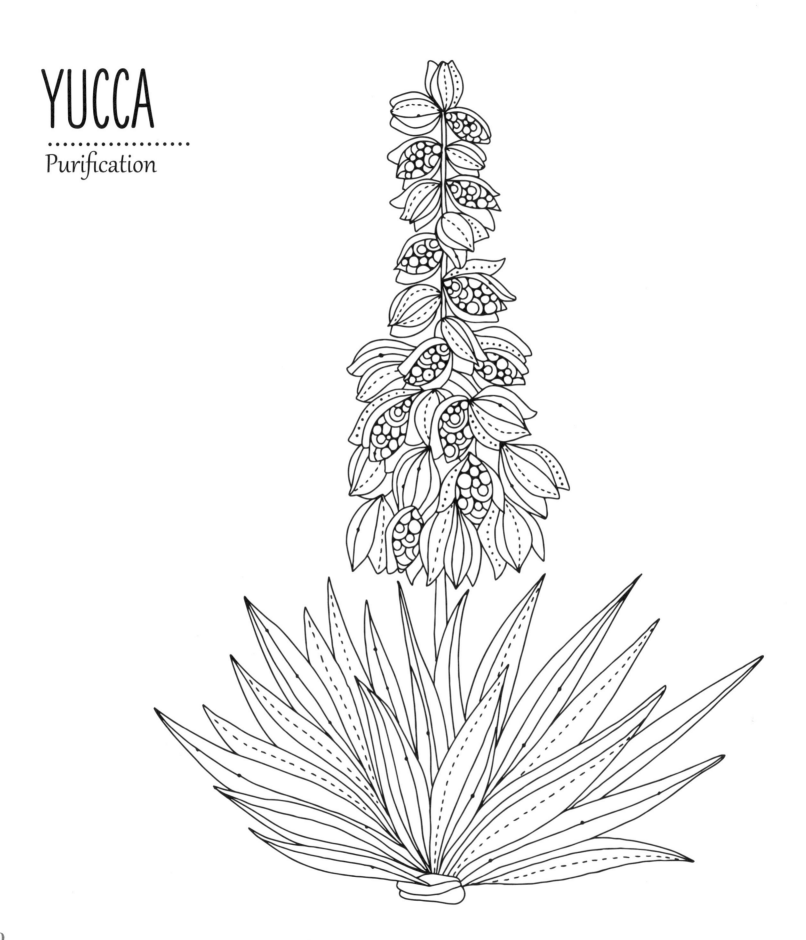

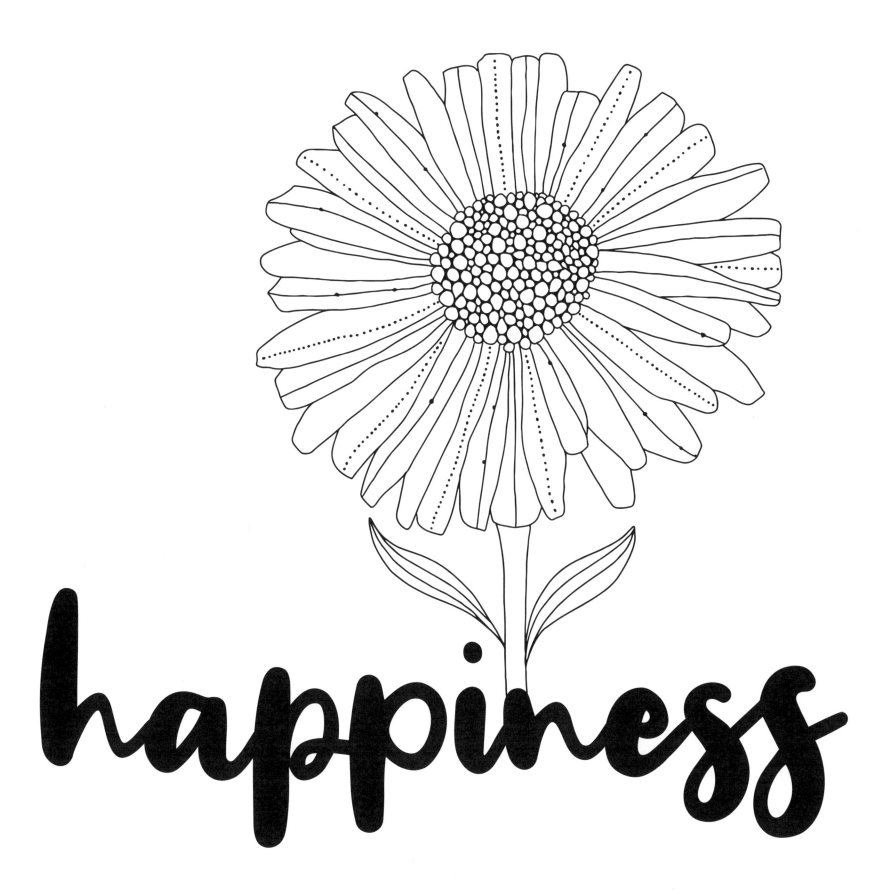

GO OUTSIDE AND LOOK AROUND

What plants and flowers do you see?

..

..

..

Draw and color what you see!

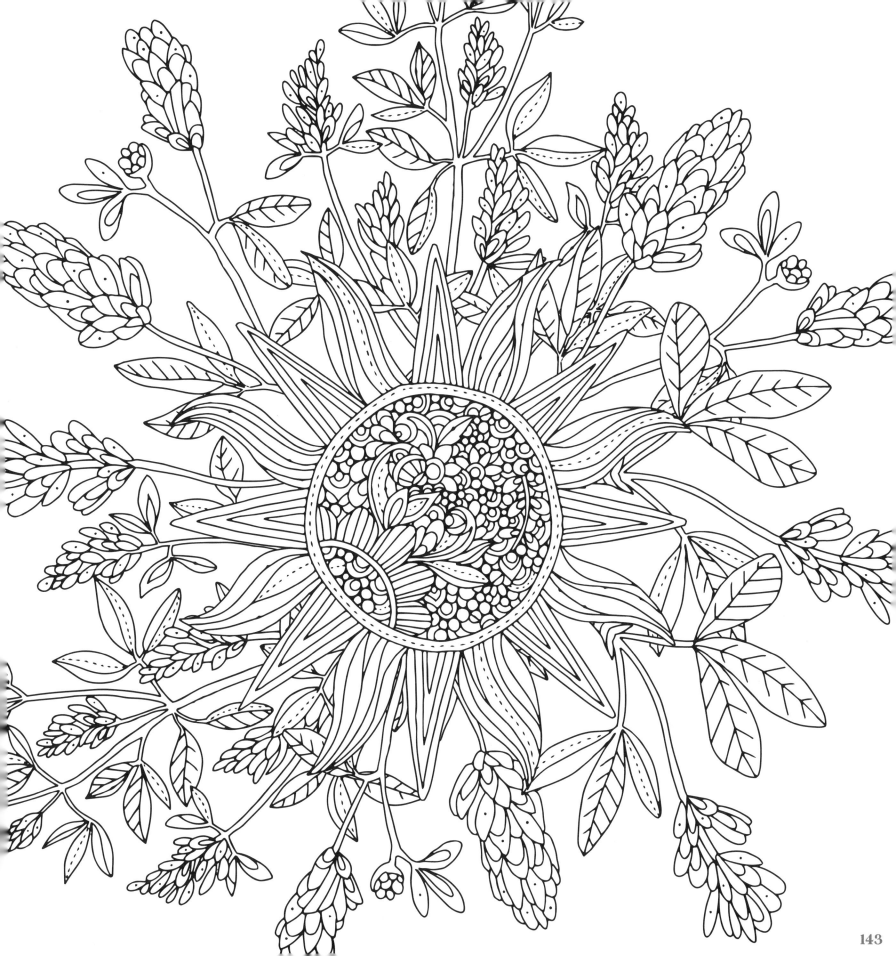

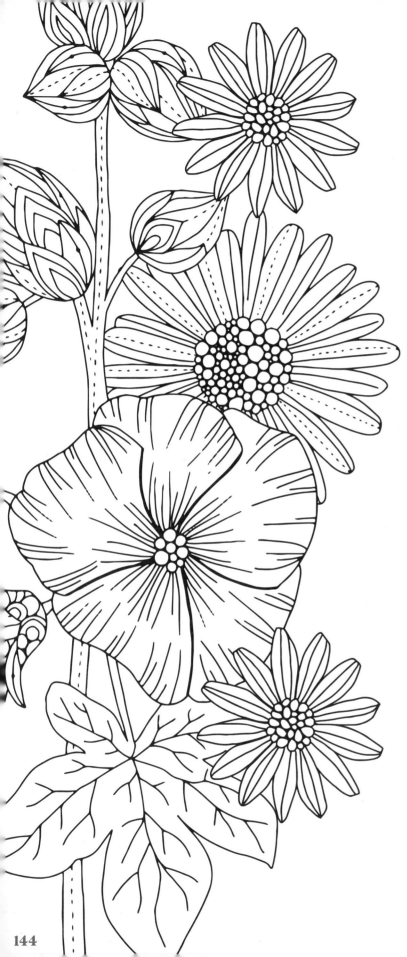

RESOURCES:

– *1001 Symbols* by Jack Tresidder
– *The Natural History Book* by David Burnie
– *Language of Flowers* by Kate Greenaway
– *www.atozflowers.com*
– *www.flowermeaning.com*
– *www.almanac.com*
– *www.remedieshouse.com*
– *https://en.wikipedia.org/wiki/Plant_symbolism*

FLOWER MEANINGS:

Flowers and symbols have different meanings to different cultures. The flower meanings given in this book were based on the author's investigation and point of view. Some flowers have more than one meaning— even within a single culture or tradition—but only some are given here. It's really a rich world of potential meanings out there—explore it!